THEN & NOW®

VIRGINIA BEACH

OPPOSITE: This iron fence surrounds the small family cemetery of the J. A. Fentress family. The rustic iron of the fence post provides a sense of time gone by when juxtaposed against the lush landscape of the countryside. (Courtesy of Timothy McMahon Pope.)

VIRGINIA BEACH

Amy Hayes Castleberry

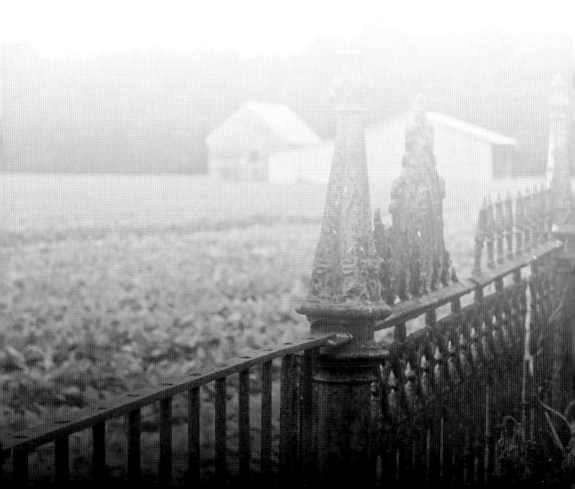

I dedicate this book to the memory of my mother, Laura Bonney Hayes, who instilled her passion for history, architecture, and all things beautiful in her four daughters. To my sisters, Missy, Betsy, and Nancy, for all the wonderful sojourns into the countryside in the quest of finding the next old house. To my brother-in-law, Tim, for his fine artistic eye in taking these photographs. To my four children, Nicholas, Jackson, Sarah, and Cary, and to my daughter-in-law, Michelle, for their love and encouragement. To all the friends, family, and foot soldiers out there who are making a difference in being good stewards of our past.

Library of Congress Control Number: 2009930544

Published by Arcadia Publishing
Charleston, South Carolina

Printed in the United States of America

Then and Now is a registered trademark and is used under license from
Salamander Books Limited

For all general information contact Arcadia Publishing at:
Telephone 843-853-2070
Fax 843-853-0044
E-mail sales@arcadiapublishing.com
For customer service and orders:
Toll-Free 1-888-313-2665

Visit us on the Internet at www.arcadiapublishing.com

ON THE FRONT COVER: The Lynnhaven House in the 1940s, with its porch, brackets, and shingled dormer with shed roof, was unrecognizable as a significant structure of the Colonial period. With all of the exterior additions peeled away, the Lynnhaven House stands as a charming museum, serving to educate modern-day visitors about life in Virginia in the 1700s. (Then photograph courtesy of the Sargeant Memorial Room, Norfolk Public Library; now photograph courtesy of Timothy McMahon Pope.)

ON THE BACK COVER: The historic Cavalier Hotel had a horse show on its grounds in the 1930s. (Courtesy of the Sargeant Memorial Room, Norfolk Public Library.)

CONTENTS

Acknowledgments		vii
Introduction		ix
1.	The Chesapeake Bay	11
2.	Lynnhaven River to the Ocean	25
3.	Eastern Branch, Kempsville, and New Town	37
4.	Eastern Princess Anne County	53
5.	The Pungo and Blackwater Regions	75
6.	Virginia Beach's Oceanfront	85
Bibliography		95

ACKNOWLEDGMENTS

It is difficult to fully express the gratitude I have for the diligence and work provided to me by the following:

My friend Robert Hitchings, the archivist, and Bill Inge, both at the Sargeant Memorial Room at the Norfolk Public Library, for bending over backwards to help me in every way.

Dr. Steven Mansfield at Virginia Wesleyan College, whose door was always open, and who provided me with gentle advice and assistance whenever I needed it.

Mark Reed, historic resources coordinator for the City of Virginia Beach Department of Museums, for carving time out of his busy schedule to give me guidance.

To all of these men for making the effort to share photographs and resources, I am so grateful.

Theresa Dunleavy and the staff at the Virginia Beach Central Library for their cheerful and tireless assistance and for coming through no matter what the circumstances.

Nick Luccketti of the James River Institute for Archaeology for his guidance and advice.

My friend John Quarstein, for his help and guidance, and my friend Buzz Cobb, for scouting out old houses while in the field.

Elizabeth Bray of Arcadia Publishing for her kindness and patience—we did it!

Tim Pope, whose artistry in photography has made all the difference; all now photographs were taken by Tim unless otherwise noted.

My sister, Nancy Hayes Pope, for her skill in cartography, geography, and computers.

My son, Nick Castleberry, for his prowess with computers, and Peter Pope, for saving the day.

Tom Beatty of the deWitt Cottage for his kindness and assistance.

To the warmth, graciousness, and hospitality of the people who let us into their lives: the owners of Old Comfort, the Richard Murray house, Poplar Hall, Tallwood, Lower Wolfsnare, the John James House, the Ewell House, Broad Bay, the Thomas Murray House, the Carraway House, the Thomas Woodhouse House, Broad Ball Manor, the Hermitage, Brown's Tavern, Fox Hall, Heritage Plantation, the Baxter Farm, and Buyrningwood. To the residents of the Bell House and the guardians of Ferry Farm. We are in your debt.

Finally, to the many friends who serve with me on the Board at Lynnhaven House, the Association for the Preservation of Virginia Antiquities (APVA), the Norfolk Preservation Alliance, and the Preservation Watchdogs, and to the docents and caretakers and Tidewater citizens who love, appreciate, and stand watch over our beautiful history. Thank you.

The use of *c.* in the caption title indicates the approximate date a structure was built.

INTRODUCTION

Some 80 years ago, a woman named Sadie Kellam set out on a road trip with her husband, V. Hope Kellam, to document the historic houses of Princess Anne County in Virginia Beach, Virginia. Armed with a small camera, her intent was to chronicle not just the grand houses of the wealthy, but the lesser houses of the area as well. In doing so, she captured the essence of the early settlers of the area, telling their story through the houses they built. She had no idea that her book, diligently researched, would become a bible of sorts for people who love the rich history and antique architecture of Princess Anne County, Virginia.

Fifty years ago, Mrs. William Miller, Mrs. Bagley Walker, and Mrs. Crawford Syer picked up the torch and went to chronicle what was left standing in their time. The slides and photographs of their work are archived at a local college. It was our intent to again pick up the torch and chronicle what is left. Sadly, that was very little. Storms and neglect have claimed some of the properties. But even worse has been the human stamp of rampant development and insensitive land use. Perhaps the saddest fate to befall a historic property is death by developer. The City of Virginia Beach has created a historic commission whose purpose will be to flag endangered properties and endeavor to protect them. Virginia Beach is finally rallying around some of its antiquities and will flag many of the historic structures that are left. It is hoped that more of these will be included in this plan.

The making of this book has been a fascinating journey. We pored over old maps, studying roads, byways, and thoroughfares that are long gone. Some were incorporated into the greater metropolitan area, or melded into the Naval Air Station at Oceana. We found colorful names defining the necks and ridges that abound in this region: necks with names like Great Neck, West Neck, and Little Neck that still stand today, and ridges with names like Rattlesnake, Possum, Chincapin, Black Walnut, Cow Quarter, and Pungo. All that is left of some prominent villages, plantations, or families are the names they lent to streets or neighborhoods.

The streets themselves have gone through their own evolution. New Shell Road and Indian River Turnpike Road turned into Gum Swamp Road, and all three became Indian River Road. The old Pungo Ridge Road, the highest point in the area, became modern day Princess Anne Road, General Booth Boulevard, and Oceana Boulevard.

Through careful research and translation of oral memories onto modern-day maps, we attempted, to the best of our abilities, to pinpoint the exact locations of once-thriving homesteads, farms, and communities and show what is there today.

After completing this work, our vision has been forever changed. The old maps revealed houses and homes, small farms, and grand plantations all over the landscape. We find ourselves looking at every grouping of trees, at every bend of the road or creek, and wondering what once stood there, erased for all time from the greater cityscape.

Thomas Jefferson was said to have visited the great cities of Europe hoping to take the best of what they had to offer and paint those ideas onto the blank canvas of the American landscape. Today we ask ourselves: did we fulfill his vision?

THE CHESAPEAKE BAY

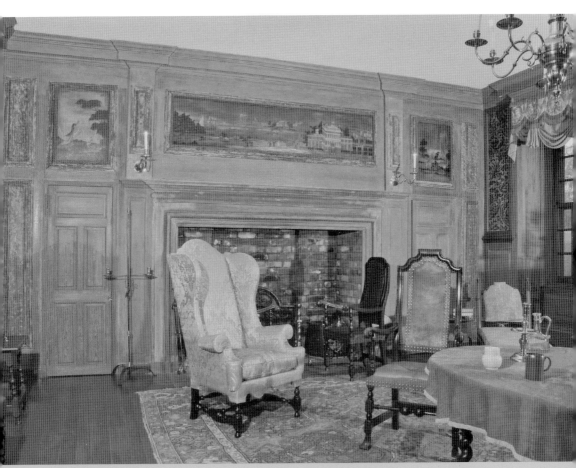

EASTWOOD MANTEL. This mantel, now in the Flock Room of Winterthur Museum, once graced Eastwood, a beautiful early brick house that was located off Great Neck Road. The curator of Winterthur saw the beauty of the piece and retrieved it shortly before the house was torn down in the 1940s. It is being displayed as a fine example of Colonial interior woodwork. (Courtesy of the Winterthur Museum.)

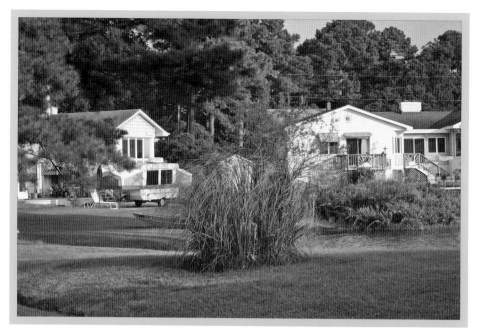

ORIGINAL THOROUGHGOOD SETTLEMENT. Adam Thoroughgood arrived in Virginia as a 17-year-old indentured servant aboard the ship *Charles* and is thought to have bestowed the names Lynnhaven and Norfolk on the area. In 1635, Adam Thoroughgood is believed to have moved to his property at Lynnhaven, where he constructed a dwelling house substantial enough to hold court meetings and Anglican church services. Thoroughgood's home had the earliest documented dining room in Virginia. A neighborhood stands on the grounds of one of Virginia's earliest settlements. (Drawing courtesy of Jamie May and Nick Luccketti.)

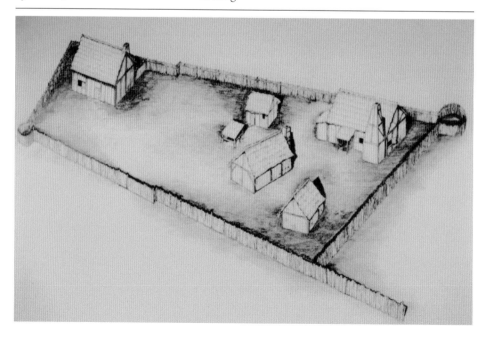

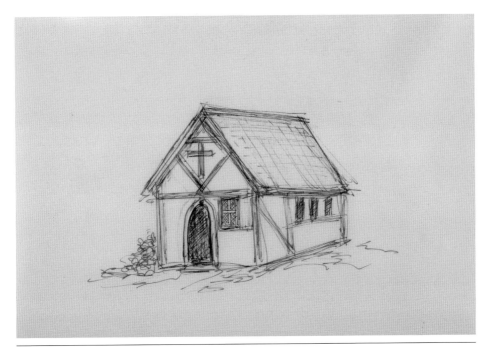

CHURCH POINT, C. 1639. The church that stood here on the western shore of the western branch of the Lynnhaven River was believed to have been built by Adam Thoroughgood around 1639. The first vestry for Lynnhaven Parish was elected in 1640. By 1691, the church had become "ruinous" and was abandoned as the river took over the grounds. In 1819, Commodore Stephen Decatur described wading in the river and standing on the tombstone of Adam Thoroughgood. Three Thoroughgood children are also buried here: Sarah, Adam, and an unknown child. (Drawing by Amy Castleberry.)

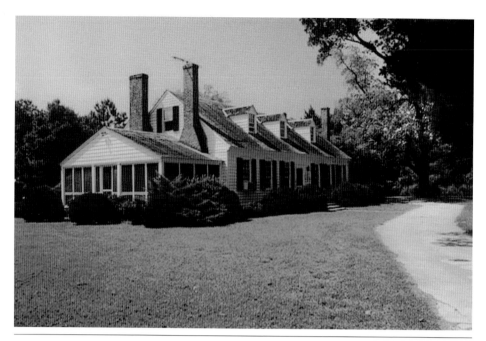

THE HERMITAGE, c. 1699. The Hermitage is a charming one-and-a-half-story farmhouse constructed in three stages. The first stage dates to around 1699, when John Thoroughgood built his house on Adam Thoroughgood's Grand Patent, and the last stage dates to 1940. The house sits across the inlet from the Adam Thoroughgood house and was a working farm until the 1950s, when it became the foundation for the first development of Virginia Beach. The house was once owned by Adm. John Beling, commander of the USS *Forrestal*. This beautiful house sits on a quiet street and is privately owned. (Courtesy of the owners.)

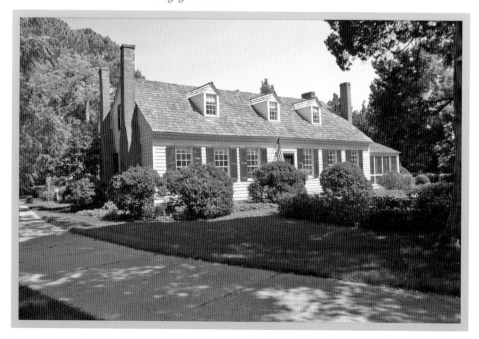

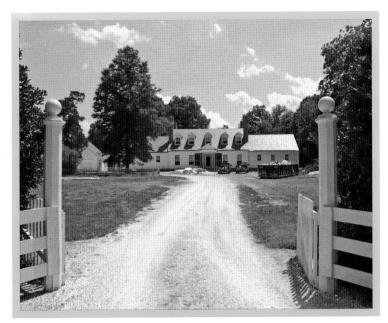

BAYVILLE, 1827. Bayville was built on original Thoroughgood lands by Peter Singleton, a Thoroughgood descendant who grew up at Pleasant Hall. A small frame house that stood behind the main house had the initials "J. T." in one of the chimney bricks for John Thoroughgood. Peter Singleton was known to have extravagant taste, favoring expensive velvet clothing with solid gold buttons. He inherited wealth on both sides of his family but lost most of it about the same time he was building Bayville. The house was lost in a card game a year after its completion. The owner expanded the lands in 1828 and owned 50 hounds, a stable of fine Arabian horses, and a racetrack. The original house was destroyed by lightning in 2007. (Courtesy of Virginia Wesleyan College.)

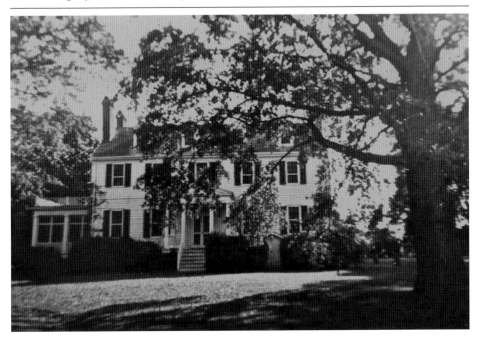

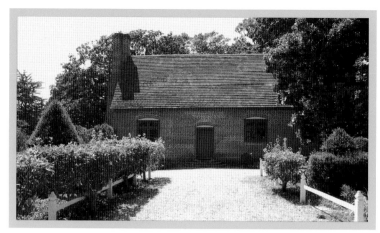

ADAM THOROUGHGOOD HOUSE, *c.* 1720. The Adam Thoroughgood House is one of the most locally famous structures in Virginia Beach and illustrates the transition from the frontier shelters of the 17th century to the more established structures of the 18th-century gentry. It is considered to be post-medieval in style, with massive end chimneys and irregular placement of doors and windows. It was opened to the public in 1957 and was at one time billed as the oldest brick house in America. Recent archaeological evidence points to a date somewhere around 1720, built probably by a descendant of Adam Thoroughgood. (HABS photograph courtesy of Meyera E. Oberndorf Central Library.)

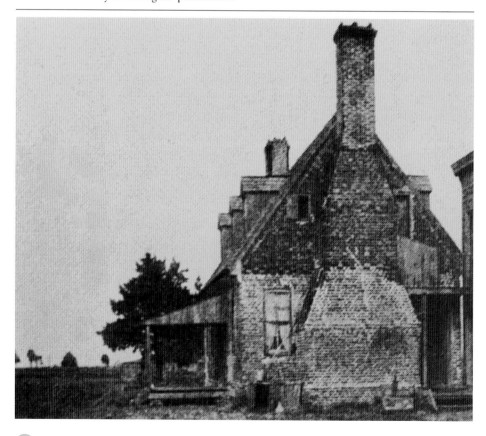

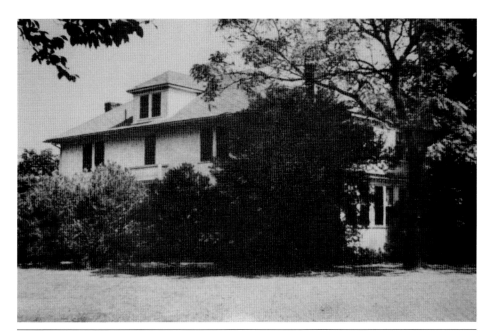

LAWSON HALL. The first patent for this great estate was granted in 1673 to Anthony Lawson and consisted of 490 acres, which were subsequently added upon. The house that history remembers was probably built by Col. Anthony Lawson, who died in 1785. The house burned in the early 20th century, when a windborne spark caught the moss-covered wood shingles on fire. All that remained were "the marble steps and flags, boxwood, beech trees, cedars which formed the garden wall," according to Sadie Kellam in 1931. A small bridge and stream are intact. The house that stands today was built on the original footprint of the old manor house but bears no resemblance to the original. (Courtesy of Virginia Wesleyan College.)

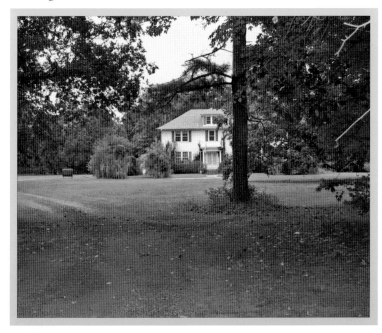

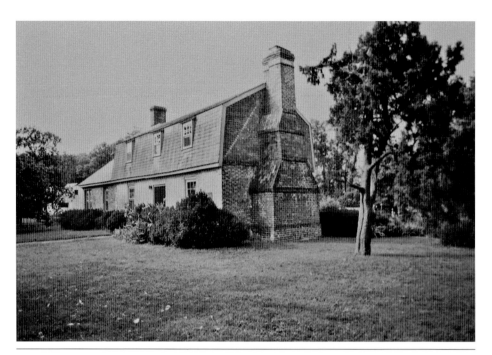

WEBLIN, EARLY 1700S. Weblin was probably built in the early 1700s on land granted to Thomas Lambert in 1648. It took its name from John Weblin, who married Thomas Lambert's daughter. It has also been called Moore Farmhouse. It originally had the sharp roofline associated with the very early houses of the region, but the roofline was changed to a gambrel some time in the early 19th century. The Widow Moore operated Weblin as a farm into the 1980s, renting vegetable garden plots to city dwellers. The ancient house is completely surrounded by the Cypress Point neighborhood. (Courtesy of the Sargeant Memorial Room, Norfolk Public Library.)

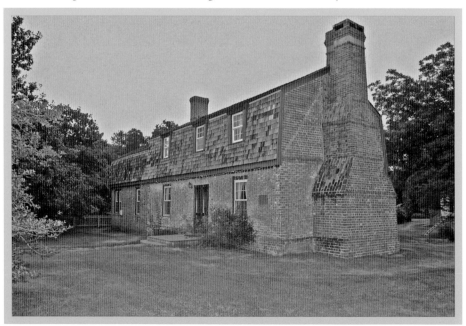

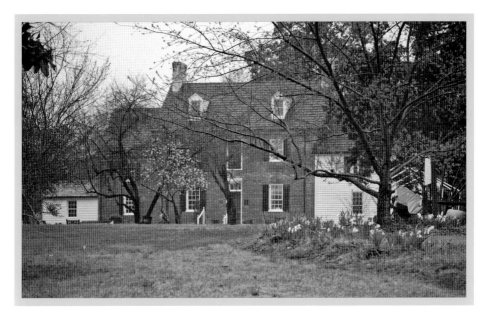

FERRY PLANTATION, *C.* 1830. Ferry Plantation was the residence of Col. Anthony Walke, built from the best bricks that survived the fire that destroyed the Walke Manor House in 1828. The Federal-style house was the site of a ferry that operated from 1642 into the 19th century and was located near the third Princess Anne County Courthouse. The efforts of a group of citizens kept Ferry Plantation from being torn down when the area was being developed. The house is now a museum. (Courtesy of the Sargeant Memorial Room, Norfolk Public Library.)

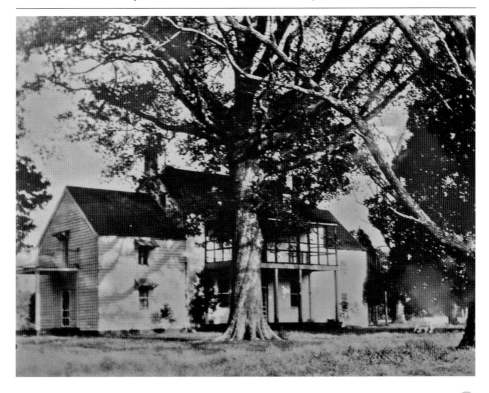

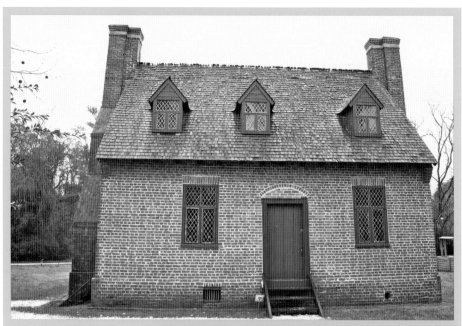

LYNNHAVEN HOUSE, c. 1725. Lynnhaven House, brick with English bond, is a stunning example of Tidewater Virginia vernacular architecture. It is situated on a finger of the Lynnhaven River and has also been known as the Wishart House and the Boush House. It was occupied until the 1970s, despite the fact that there was no running water or indoor plumbing. It is now owned by the city of Virginia Beach and operated as a museum. Out of its original 250 acres, only 5.5 remain. The house offers wooded trails, a garden, and a small Revolutionary War cemetery. (Courtesy of the Sargeant Memorial Room, Norfolk Public Library.)

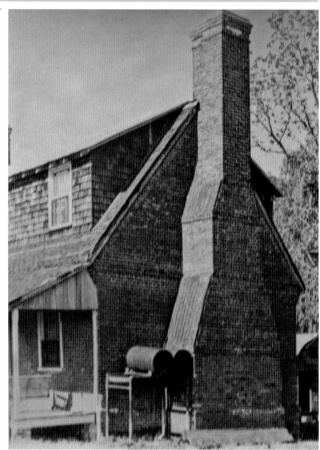

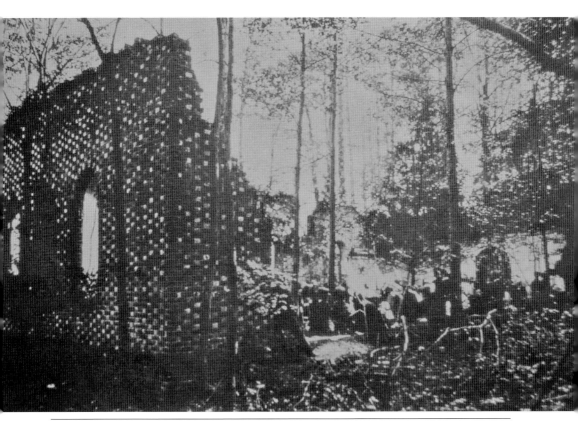

OLD DONATION CHURCH, *c. 1736*. Old Donation Church was built as the third parish church to accommodate the growing community of Lynnhaven Parish. It takes its name from nearby Donation Farm, occupying land that was the site for the late-17th-century Princess Anne Courthouse. By 1800, it was empty, and it was destroyed by a forest fire in 1842. Services were held in the ruins of Old Donation in the late 1800s, and the church was restored to new life in 1912 and is still in use. (Courtesy of the Sargeant Memorial Room, Norfolk Public Library.)

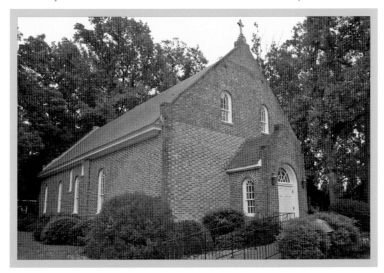

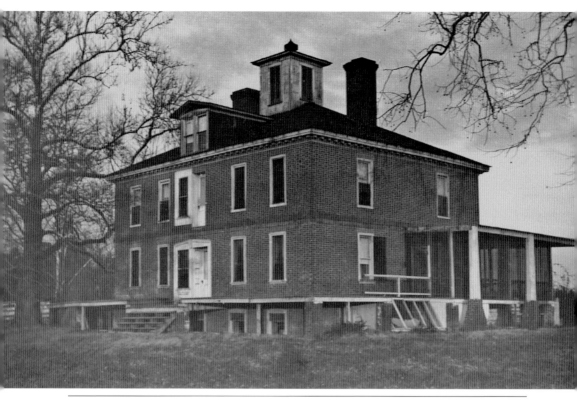

PEMBROKE MANOR, C. 1764. Pembroke Manor is a Georgian Flemish bond brick structure with two interior chimneys and beautiful interior woodwork. The original builder, Jonathan Saunders, only lived a year after the completion of his home. His colorful son, Capt. John Saunders, was a Loyalist who fought for the British during the Revolutionary War and was subsequently evicted from the land while Thomas Jefferson was governor of Virginia. He eventually went to New Brunswick, Canada, where he built a house very similar to Pembroke Manor. The house is currently being used as a school. (Courtesy of the Sargeant Memorial Room, Norfolk Public Library.)

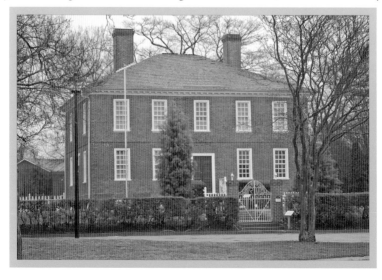

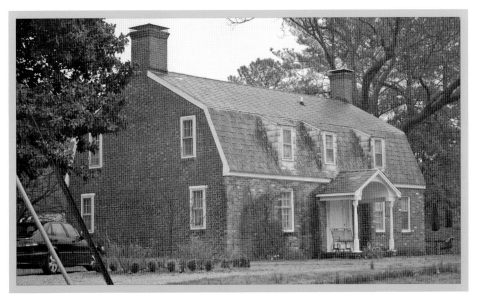

BIDDLE HOUSE, 1752. The Biddle House dates to 1752, begun some time after John Biddle acquired the property in 1740. An early photograph shows the house to be frame with brick end chimneys. Much of the construction is original, with signatures of the craftsmen found on the interior frames. In the 1930s, the Biddle house was visible from Little Neck Road, which led to the glebe, a farm that supported the Anglican Church priest. At the time the Biddle house was erected, the glebe lands comprised what are now Middle Plantation, Seabreeze Farms, and King's Grant. The house is privately owned. (Courtesy of the Sargeant Memorial Room, Norfolk Public Library.)

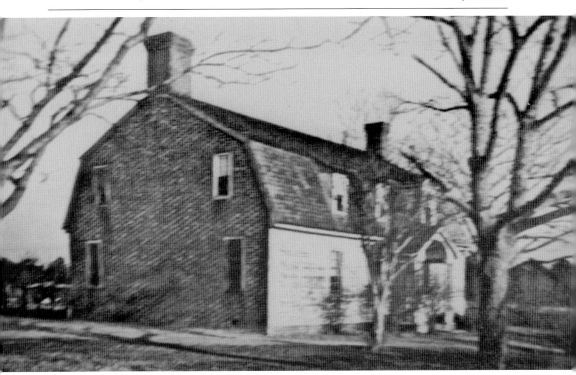

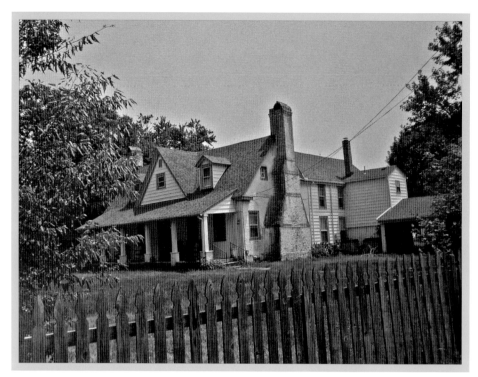

FOX HALL, *c.* **1720.** Fox Hall is an early house with a sharp roof and massive end chimneys. Legend has it that the name Fox Hall came from the time a fox ran into the house from the surrounding fields. Confederate soldiers are purported to have hidden in the chimneys during the Civil War when Union soldiers approached. The home was offered to the City of Norfolk in the 1970s as a historic site, but the offer was retracted after the city said it would tear it down and erect a plaque at the location. The house is privately owned. (Courtesy of Irwin Berent, NorfolkHistory.com.)

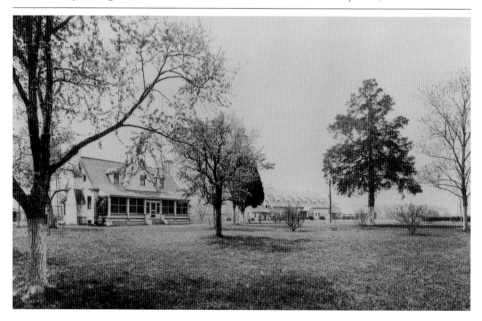

CHAPTER 2

LYNNHAVEN RIVER
TO THE OCEAN

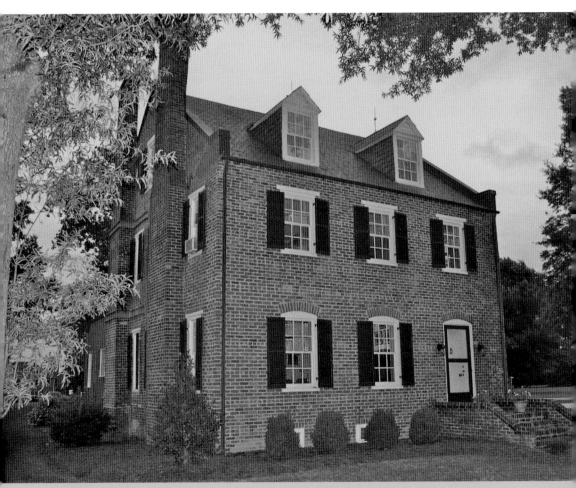

OAK HILL, c. 1830. Oak Hill was constructed in the Federal style of brick made on site by the Woodhouse family. In the basement is a remnant of a foundation from an earlier structure. (Courtesy of Timothy McMahon Pope.)

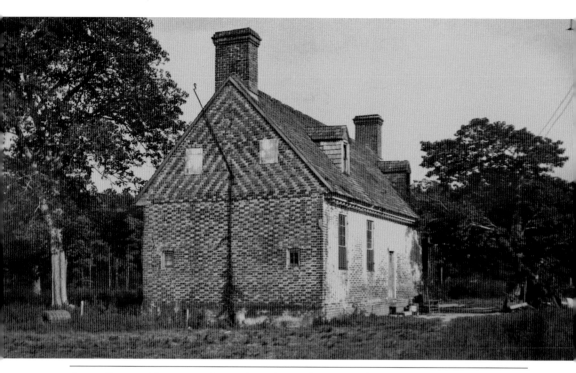

ADAM KEELING HOUSE, c. 1735. The Adam Keeling House is an example of the vernacular/post-medieval manor house with intricate chevron on the end gables. It was earlier known as "Ye Dudlies." At one time, it consisted of 400 acres and extended south to London Bridge. In 1931, Sadie Kellam remarked that "the old garden is almost completely gone, a crepe myrtle or so being all that is left. . . . The house is in unusually sound condition." The Adam Keeling House and the gardens have been restored to their former glory. The house is privately owned. (Courtesy of the Sargeant Memorial Room, Norfolk Public Library.)

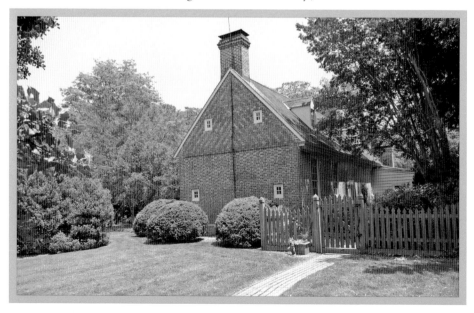

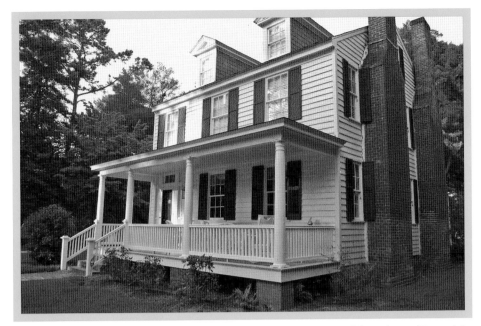

OLD COMFORT, *c.* 1822. Old Comfort is also known as the Henry Woodhouse House after a seventh-generation inhabitant of Princess Anne County. The house is built on the original 1630 grant, and the timbers used in its construction were logged from what is now First Landing State Park. They were floated through Broad Bay and the Narrows into Linkhorn Bay and hauled to the site. The hand-hewn heart-of-pine logs can still be seen in this beautiful home. The bricks were made by slaves from local clay. (Courtesy of the owners.)

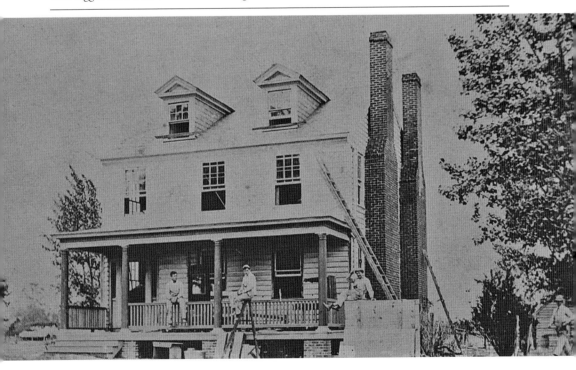

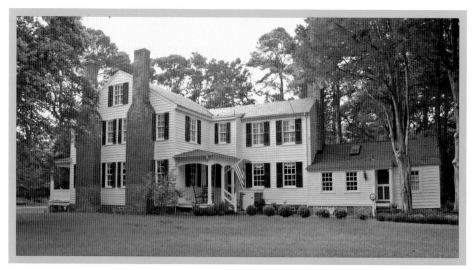

OLD COMFORT. Henry Woodhouse was deaf from a childhood illness, which prevented him from serving in the Confederate army. He was a friend of Robert E. Lee, who visited him at this house. Loyal to the cause, he donated strawberries and spinach from the farm to the Southern soldiers. Old Comfort is tucked away in an upscale neighborhood in an idyllic setting. It is a warm and inviting place, a testimony to its owners both past and present. (Courtesy of the owners.)

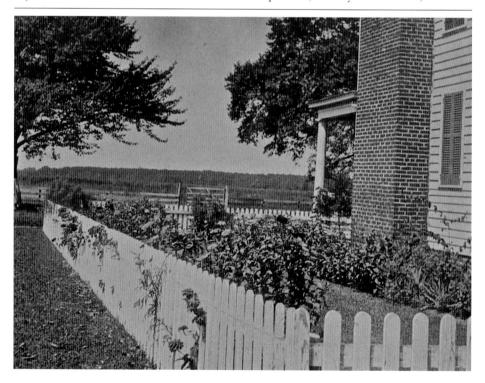

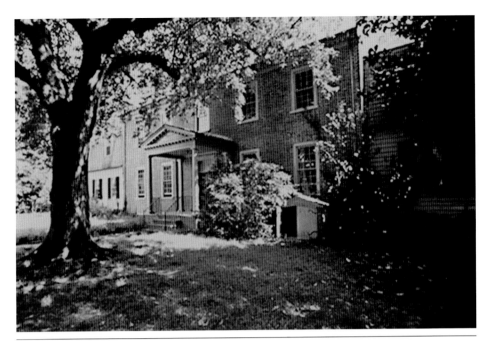

GREEN HILL, 1730S. Green Hill was built prior to 1738 by either Lancaster Lovett or his son John. It is not known if that was the original name of the plantation; it was referred to as Green Hill in records after 1837. Green Hill started as a four-room house and was expanded in 1791, the date found on an exterior brick, during Lemuel Cornick's ownership. The house is a private residence. (Courtesy of Meyera E. Oberndorf Central Library.)

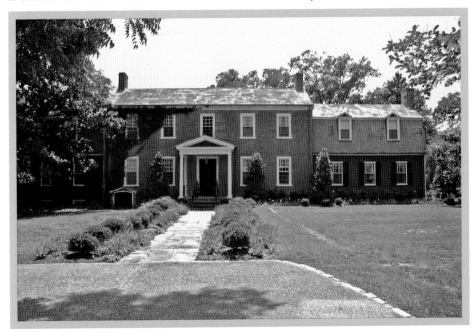

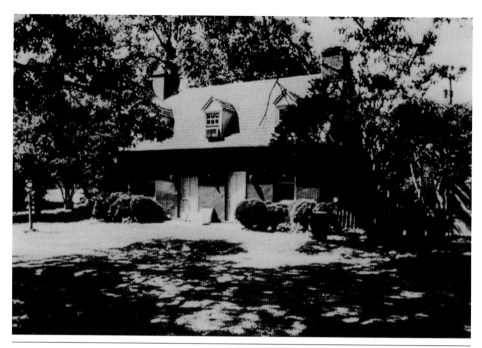

GREEN HILL. A charming two-door cottage toward the back of the property is thought to have been built by John Stratton during the mid-17th century as the first house on the site. It was once used as a kitchen to the main house. Stratton's land grant stretched along the southern shore of Broad Bay and what is now Long's Creek, formerly Stratton's Creek. (Courtesy of Meyera E. Oberndorf Central Library.)

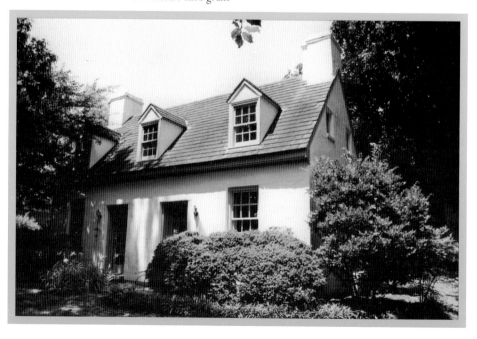

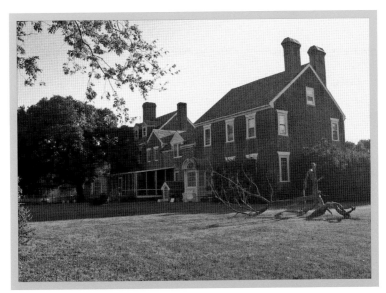

BROAD BAY MANOR, *C.* **1640.** The original house on this property was brick and consisted of one room and a loft built on a land grant to Thomas Allen. Over the years, Broad Bay Manor has been added on to and radically changed, the original house having been incorporated into the additions. The grounds are beautiful, with vestiges of an old wharf still visible near the water and an ancient graveyard tucked away in the back. (Courtesy of the Sargeant Memorial Room, Norfolk Public Library.)

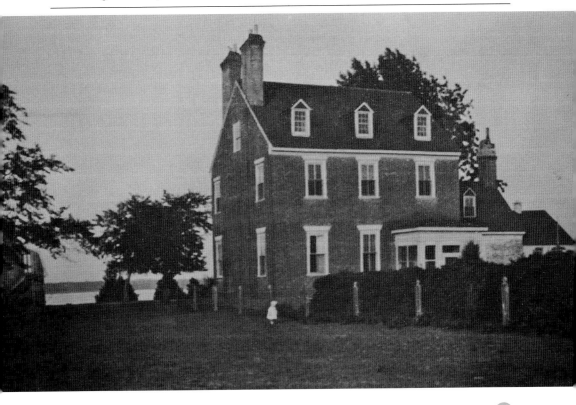

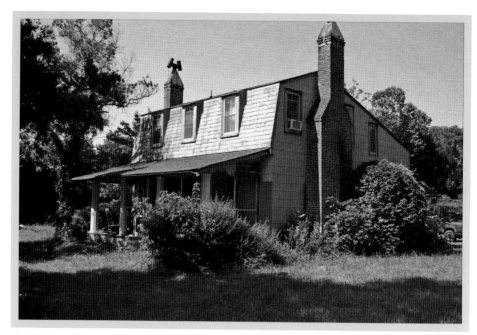

THE HORATIO T. CORNICK HOUSE. Horatio T. Cornick inherited his land from his father, Lemuel Cornick, in 1773. The three-bay house with its gambrel roof has exterior end chimneys and has been in the Godfrey family for generations. The photograph below, taken in the mid-20th century, shows the chimneys being completely replaced and rebuilt. (Courtesy of Virginia Wesleyan College.)

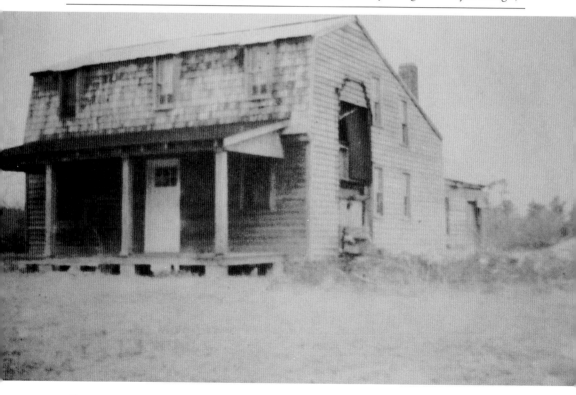

ROSE HALL, 1730. The original Rose Hall was built by Jacob Ellegood, a Princess Anne justice in 1740, on 615.5 acres patented as Thomas Cannon's Old Landing Cove. His son-in-law was William Aitchison of Eastwood. His son, also named Jacob, was a justice in 1775 but was loyal to the Crown and was exchanged by the Colonists as a prisoner for Col. Anthony Lawson of Lawson Hall. Upon his release, the younger Jacob Ellegood settled in New Brunswick, Canada, with his son-in-law John Saunders of Pembroke. (Courtesy of Virginia Wesleyan College.)

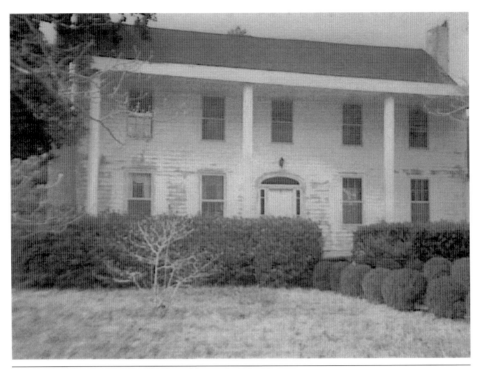

ROSE HALL. The house burned and a new structure was erected in 1820 on the footprint of the original. In 1931, gravestones could be seen in the burial plot on the property. William Aitchison of Eastwood, Ellegood's son-in-law, had a particularly fine tomb in the Rose Hall cemetery, and the double-headed eagle of his Scottish coat-of-arms was still visible on the dilapidated surface of the stone. A developer tore down Rose Hall in 2001, and the bricks line a walkway at Ferry Plantation. (Author's collection.)

LOWER WOLFSNARE, *c.* 1720. Wolfsnare is a gambrel-roofed house sitting on 1 acre of the 6.5 acres that were in the original land grant. There was a landing on the creek nearby called Pallet's Landing, after the family that built the house on the Jacob Hunter farm long ago. In 1651, the creek was called Oliver Van Hick's Creek, and later it was known as Wolf Snare Creek. In the early part of the 20th century, some of the old pits used to trap wolves were still visible. The house was used as Confederate headquarters during the Civil War and was rumored to have an underground tunnel where whiskey was smuggled. (Courtesy of the owner.)

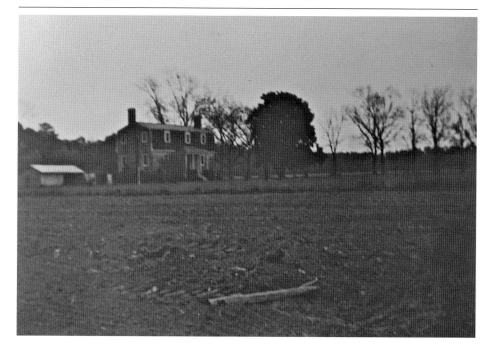

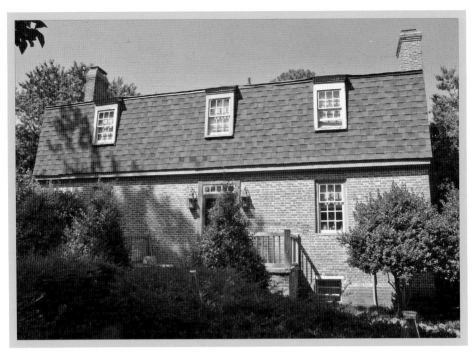

LOWER WOLFSNARE. Sadie Kellam described the house as forlorn in her 1931 book and hoped it would see better days. It has, in large part thanks to a major restoration in the late 1980s and early 1990s and continuous attention since then. The grounds are beautiful and boast a 400-year-old magnolia tree. It is hard to grasp that Lower Wolfsnare was surrounded by an unobstructed expanse of land and was at one time a landing on a waterway. This view would have been taken off present-day Great Neck Road. The house is a private residence. (Courtesy of the owner.)

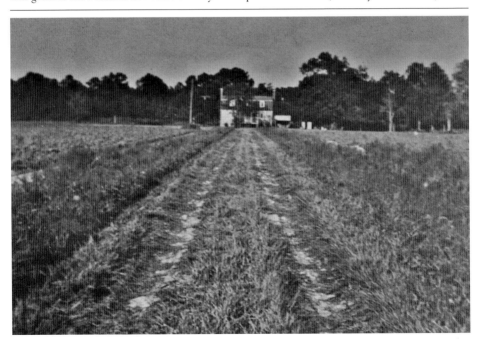

CHAPTER 3

EASTERN BRANCH,
KEMPSVILLE, AND
NEW TOWN

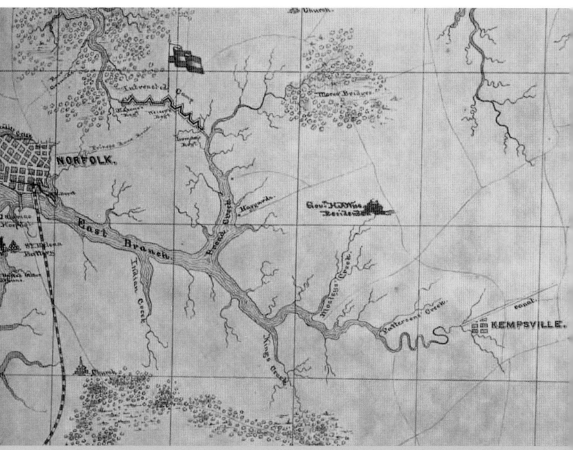

ROLLESTON HALL. This early map reveals a drawing of beautiful Rolleston Hall, now long gone, in the area near modern-day Newtown Road. (Courtesy of the Sargeant Memorial Room, Norfolk Public Library.)

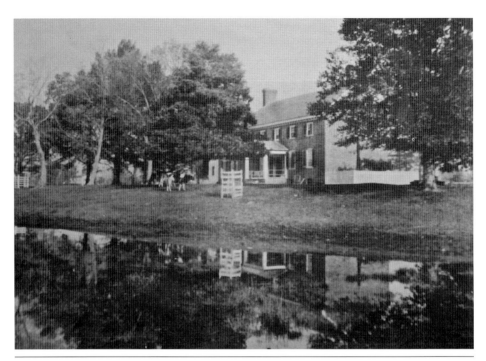

POPLAR HALL, 1767. Poplar Hall is a beautiful Georgian house built on a 1645 land grant on the eastern shore of Broad Creek. It is Flemish bond brick with a gable roof and interior end chimneys. The interior woodwork is original. There were several dwellings on the site before Thurmer Hoggard purchased the property in 1761. At the end of the 18th century, some of the first Lombardy poplars were planted along the drive, giving the plantation its name. Thurmer Hoggard was a Loyalist, but his son Nathaniel was an officer in the American army. (Courtesy of the owners.)

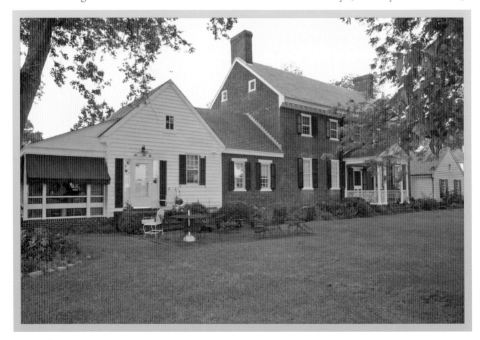

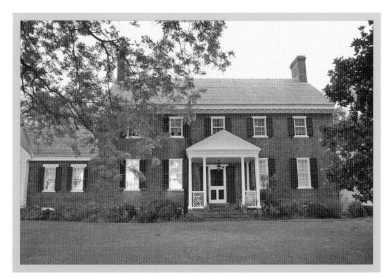

POPLAR HALL. In 1833, Chief Blackhawk stopped at the plantation well after being released from Fort Monroe. In 1854, Poplar Hall offered refuge during the yellow fever epidemic. During the Civil War, it was rumored that Poplar Hall was behind a blockade running operation, and the Union army stationed soldiers there to thwart the effort. Aunt Lucy Hopper, a slave, hid a large portion of the provisions so that the residents could be fed. After the war, she stayed on with the family and planted a butterfly bush in the yard the day Lee surrendered at Appomattox. The bush blooms to this day. (Courtesy of the owners.)

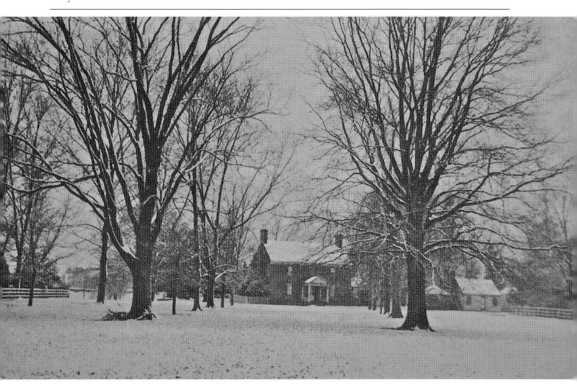

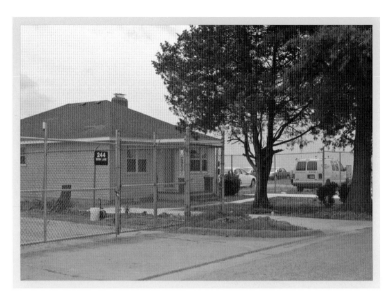

THE DENN. No evidence of the once-thriving New Town now exists. In 1931, a Judge White remembered seeing old foundations at the beginning of the 20th century. The Hancock family owned property in the area, and Simon or William Hancock built the house called Lion's Den, or "The Denn," just before 1800 at New Town Crossroads. Rev. Lewis Walke made his home there while rector at Emmanuel Episcopal Church in Kempsville in the mid-1800s. The house was a handsome two-story structure with brick ends and was still standing in the 1930s. (Courtesy of the Sargeant Memorial Room, Norfolk Public Library.)

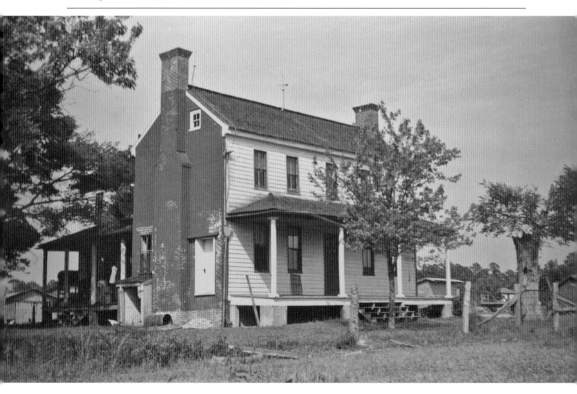

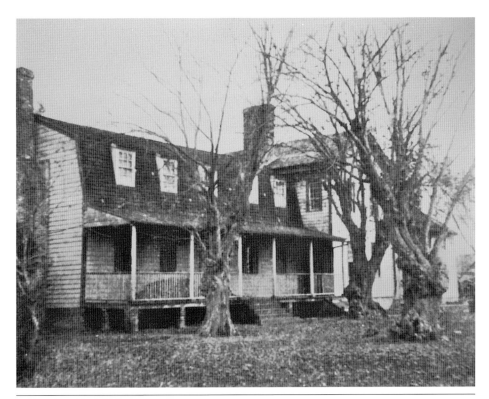

ROLLESTON HALL. In 1649, a wealthy English couple, William and Susannah Moseley, brought their family to lower Norfolk County from Rotterdam, the Netherlands. Moseley served as a steward of the English court as a member of the Company of Merchant Adventurers of London. The early house with its Dutch-style gambrel roof was clearly influenced by the Moseleys' years in the Netherlands. Generations of Moseleys served in politics throughout the Southern states. There is a wonderful story that Edward Hack Moseley of Rolleston danced with such elegance that the people of Norfolk sent for him as a dance partner for the royal governor's wife. The chapel at Barry Robinson occupies part of the tract of Rolleston Hill. (Courtesy of the Sargeant Memorial Room, Norfolk Public Library.)

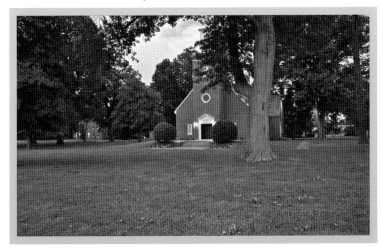

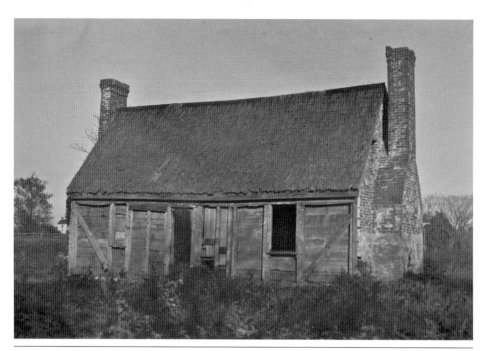

ROLLESTON HALL. By 1860, former Virginia governor Henry A. Wise owned Rolleston, but he abandoned it in 1862 when he sought refuge with his family in Rocky Mount, North Carolina, during the Civil War. When the war was over, Wise was a prisoner on parole and attempted to reclaim his home, but he was turned away by Union major general Alfred Howe Terry. At one time, Rolleston Hall served as a school for freedmen. The house burned to the ground in the late 19th century. There is a Rolleston Avenue near the grounds that certainly would have been part of the plantation. The old quarter house was all that was standing in the 1940s. (Courtesy of the Sargeant Memorial Room, Norfolk Public Library.)

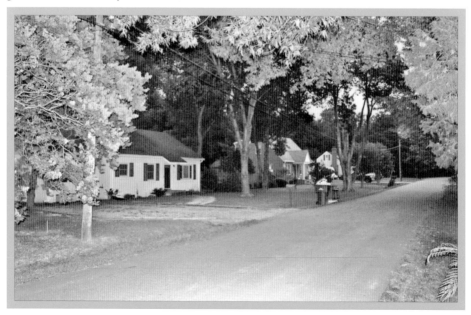

EASTERN BRANCH, KEMPSVILLE, AND NEW TOWN

GREENWICH PLANTATION. Greenwich was also located on the eastern branch of the Elizabeth River, divided from Rolleston by Mill Creek. Col. Anthony Walke married Mary Moseley of Greenwich. Edward Walke, a descendant of the family, lived at the plantation for many years until his death in 1866. Somewhere on the grounds is a Walke cemetery where Anthony Walke II is buried. There is no trace of the house or grounds that vied with Lawson Hall, Rolleston, and Fairfield as being a dispenser of hospitality. This drawing from *Harper's Weekly* in 1866 is of Rolleston. The two plantations were located near each other and were closely connected.

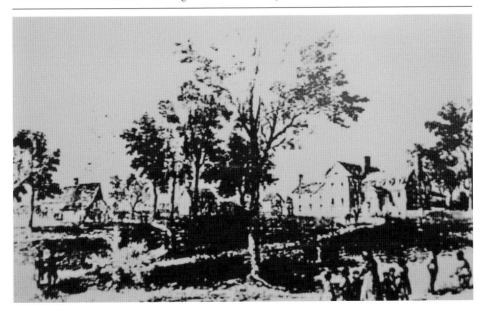

EASTERN BRANCH, KEMPSVILLE, AND NEW TOWN

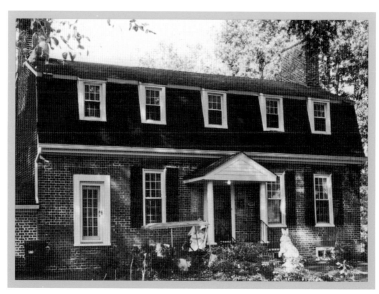

THE MURRAY HOUSES. David Murray was the first of his line to come to Princess Anne County. He arrived in 1650, acquiring land south of the Elizabeth River. The property was passed down through several generations, and in 1777, Isaac Murray inherited a plantation on King's Creek. Isaac built houses for his sons along King's Creek, situated on coves within viewing distance of one another. The Murray family made money with flax as a cash crop, making rope for the burgeoning shipping industry. All of the Murray houses feature gambrel roofs and Flemish bond brick. The Richard Murray house still has the original smokehouse behind it. (Courtesy of the Sargeant Memorial Room, Norfolk Public Library.)

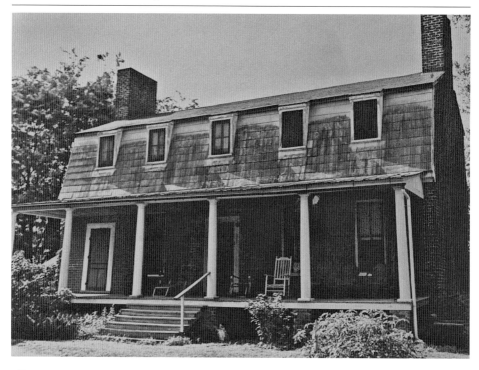

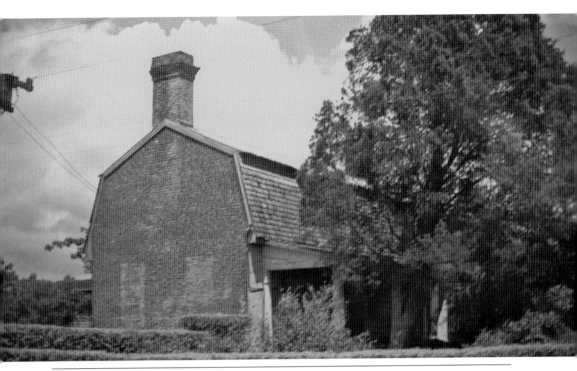

THE THOMAS MURRAY HOUSE. The Thomas Murray House, while similar in construction, has a different style chimney. Although the Richard Murray and the Thomas Murray Houses are surrounded by neighborhoods, both evoke a feeling of serenity once on the grounds. The water views are peaceful, and each house still has a pleasant sense of timelessness. Both houses are privately owned. (Courtesy of the owner.)

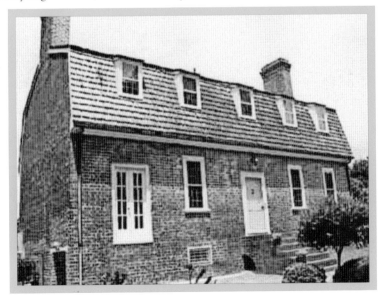

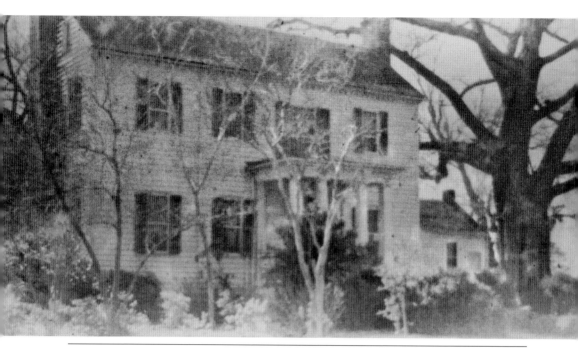

LEVEL GREEN. Simon Hancock sold property to Anthony Lawson and Edward Moseley in 1697 for New Town and built a house for himself on the south side of the Elizabeth River. His grandson, William, bought a house and 180 acres, calling it Level Green, which stayed in the family for many years. The structure was Flemish bond brick and had a gambrel roof. In 1833, a Mr. Herbert built a large frame house with end chimneys. Although Level Green existed in 1930, the only trace of it now is in the name of the neighborhood and street. (Courtesy of the Sargeant Memorial Room, Norfolk Public Library.)

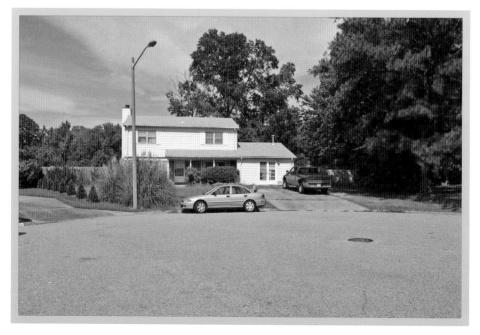

EASTERN BRANCH, KEMPSVILLE, AND NEW TOWN

THE OLD JAIL AT KEMPSVILLE, *C.* 1789. This jail was located behind Pleasant Hall on land donated by Peter Singleton. Singleton bought Pleasant Hall in 1777, after the original owner, a Loyalist, fled to England when his lands were confiscated during the Revolution. The structure represented a time when Kempsville was a major urban center. It was the seat of the county courthouse from 1778 until 1823, when the courthouse was moved to Princess Anne County. (Courtesy of the Sargeant Memorial Room, Norfolk Public Library.)

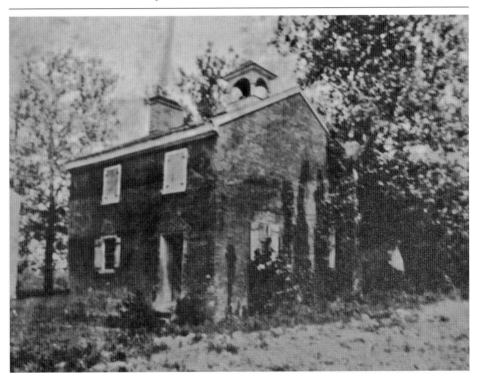

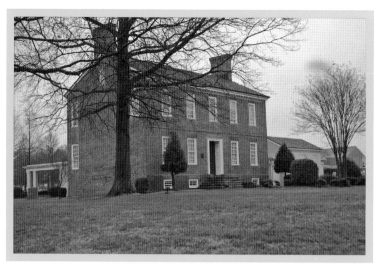

PLEASANT HALL, *c.* **1769.** Pleasant Hall is an imposing second-period Georgian house of Flemish bond brick. It has one of the most beautiful interiors in the area. George Logan, a merchant, was the builder of Pleasant Hall and served as a justice of the peace. He was a Royalist and allowed Lord Dunmore to use the house for his headquarters after the skirmish at Kemp's Landing in 1775. He gave a victory ball for Lord Dunmore at the house after the Battle of Great Bridge. Lord Dunmore wrote that he had seen Logan's house, "and [had] never seen better in Virginia." The house is owned by a neighboring church. (Courtesy of the Sargeant Memorial Room, Norfolk Public Library.)

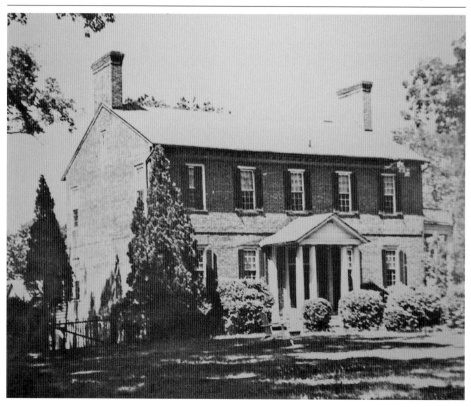

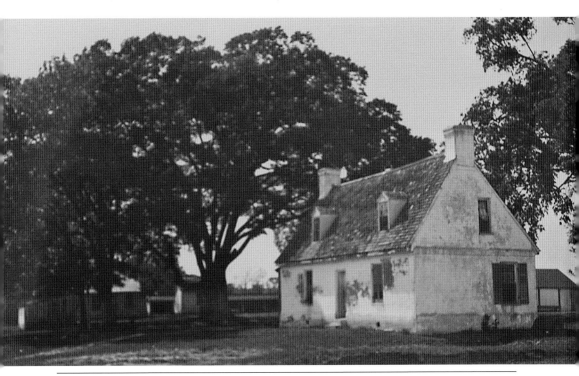

FAIRFIELD. In 1931, this little house was the only remnant left standing after a forest fire destroyed Anthony Walke's colonial plantation. Walke, along with Col. Edward Moseley of Rolleston, accompanied Gov. Alexander Spottswood and other Knights of the Golden Horseshoe on an expedition west of the Blue Ridge Mountains in 1716. This plantation was described as being almost baronial, a brick house with marble mantels, staffed with servants in livery and a contingent of saddlers, smiths, wagon-makers, and tradesmen. The house was torn down by a developer in the early 1970s. A huge tree marks its site. (Courtesy of the Sargeant Memorial Room, Norfolk Public Library.)

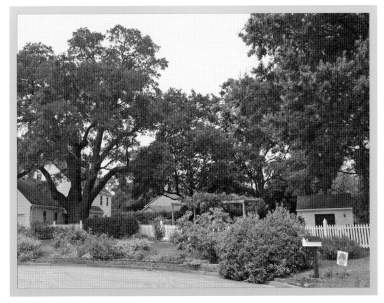

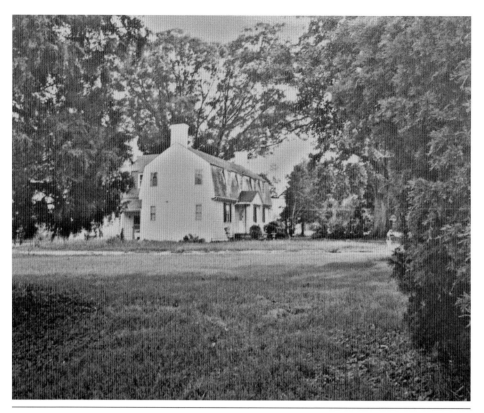

TALLWOOD, LATE 1700S. Tallwood is a one-and-half-story Dutch Colonial house, a perfect example of the type of architecture found in greater Princess Anne County from the 18th through the early 19th centuries. The style is typical of the planter elite who began to build permanent houses toward the end of the Colonial period. The book *Fifty* *Most Historically Significant Houses and Structures in Virginia Beach* states: "Tallwood is a rare survival of this house type in the northern part of Virginia Beach." Tallwood survived near-destruction by a developer. Today it is privately owned. (Courtesy of the owners.)

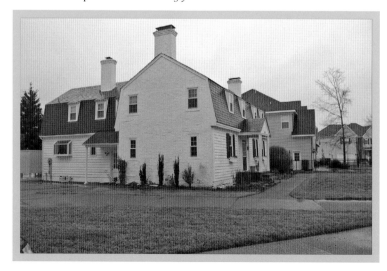

CARRAWAY HOUSE, C. 1735. The Carraway House, built by James Carraway after he purchased the site in 1733, is thought to be the earliest structure left in the village of Kempsville. It started as a hall and a downstairs room with two small rooms on the second story and was enlarged at a later time, creating the defining saltbox shape. The chimney, shutters, and many of the panes in the windows are original. The house was moved to its current location from the other side of Princess Anne Road in the 1960s, when changes were made to Witchduck Road. (Courtesy of Virginia Wesleyan College.)

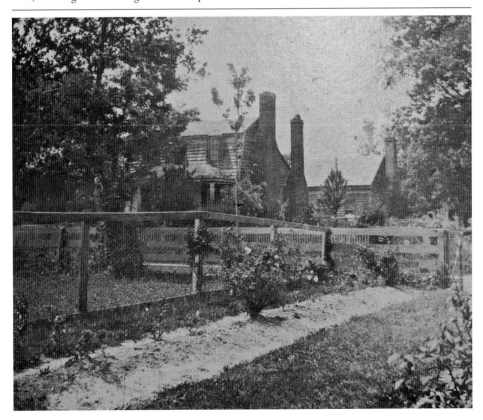

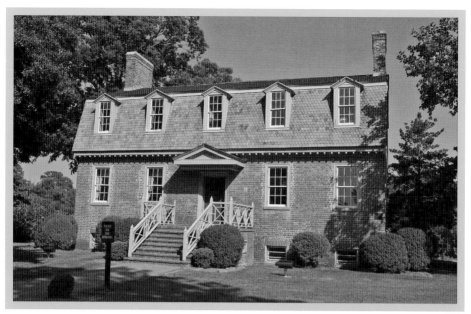

FRANCIS LAND HOUSE, 1805–1810. The Francis Land House was built when London Bridge was the closest village and Virginia Beach Boulevard was known as the Kempsville Road to London Bridge, near the Little Neck Road that led to the Glebe. The house is 18-inch-thick brick of Flemish bond with a gambrel roof and has a center passage with two rooms on either side. The Land family served the county with distinction as court justices and vestrymen. It was known to be a center of hospitality, with foxhunts, balls, and lavish suppers. In the 1930s, Raymond DeFrees hosted telescope parties at the house. The house is the headquarters for the Virginia Beach Historic Resources offices. (Courtesy of the Francis Land House.)

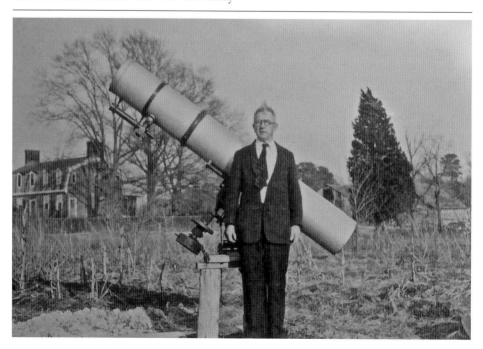

EASTERN PRINCESS ANNE COUNTY

GORNTO FAMILY HOUSE. This house was built by the Gornto family in the late 18th century. The site comprised 500 acres patented in 1684 in an area of Lynnhaven Parish called Bear Quarter. It originally had a gambrel roof, which was later raised to create a full two-story house. It was perfect condition in 1931 with beautiful interior woodwork. The location of the house is unknown. (Courtesy of the Sargeant Memorial Room, Norfolk Public Library.)

UPPER WOLFSNARE PLANTATION, 1759. Thomas Walke acquired land in 1662, and Thomas Walke III built this house on it in 1759. Thomas Walke IV, a colonel, inherited the house and lived there the rest of his life. He and his cousin, Rev. Anthony Walke of Fairfield, were Princess Anne County representatives at the convention of 1788, which cast Virginia's vote to ratify the U.S. Constitution. The home was called Brick House Farm until 1939, when the Malbon family changed the name to Upper Wolfsnare. Upper Wolfsnare is open to the public one day a week during the summer months and is owned by the Virginia Beach Preservation Society. (Courtesy of the Sargeant Memorial Room, Norfolk Public Library.)

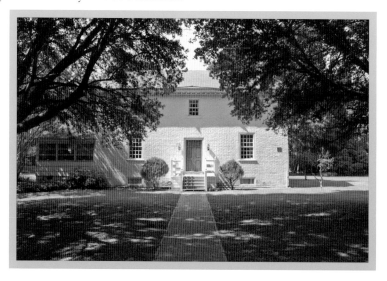

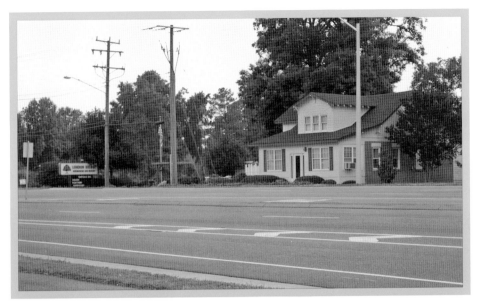

EASTWOOD. Built on the 1637 land grant of a Captain Woodhouse, Eastwood could have been his first house, built in the late 17th or early 18th century. Flemish bond with glazed headers, it was similar to the Adam Thoroughgood and Adam Keeling houses and was owned at one time by William Aitchison, son-in-law of Jacob Ellegood of Rose Hall. It was located south of London Bridge and west of Great Neck Road and was torn down in the 1940s. (Courtesy of the Sargeant Memorial Room, Norfolk Public Library.)

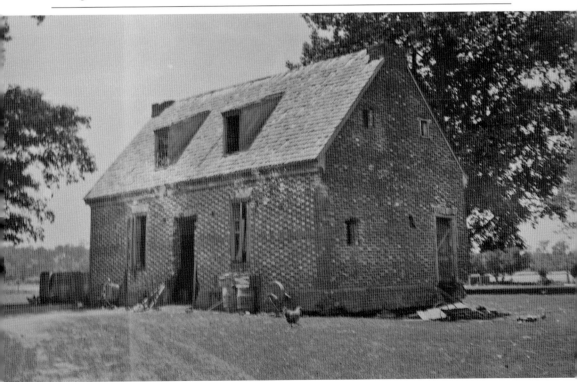

THE PERKINS HOUSE. Sadie Kellam wrote: "To a small wooden bridge over a little stream sometimes called London Bridge Creek. This location . . . has been named London Bridge. Crossing the bridge and turning sharply to the right over a second bridge, this time within a fenced field, on a hill to the left, is the home of Mrs. Perkins." Perkins was the daughter of James Edward Land, who had bought the property from Bennett Land in 1840. Land planted four cedar trees in the front yard, one for each of his daughters. Three cedar trees still stand. (Courtesy of the Sargeant Memorial Room, Norfolk Public Library.)

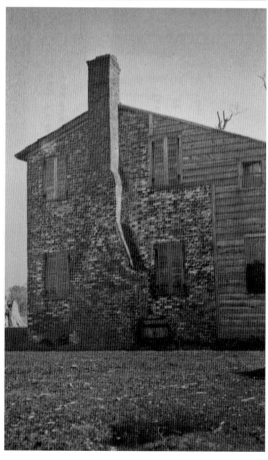

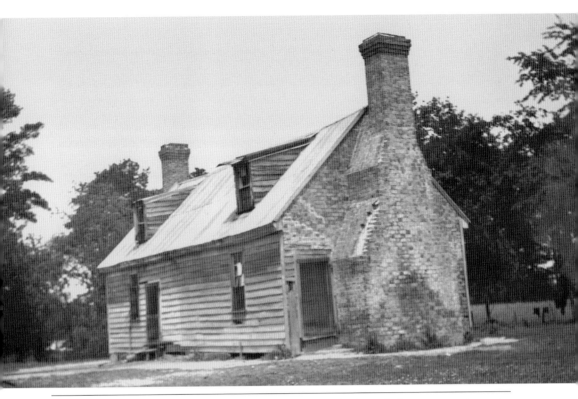

THE HUGGINS HOUSE. The Huggins plantation started off as 150 acres in the early part of the 18th century, but the land was most likely in the Huggins family prior to 1692, according to the book *Old Houses of Princess Anne County*. In 1931, this house was one of only two left in the county of its type: one-and-a-half stories, sharp roof, brick ends in Flemish bond, and one interior and one exterior chimney. The home had two rooms downstairs with an exposed staircase. All woodwork was original. At one time it was visible from Virginia Beach Boulevard on the right, heading east. By the closest approximation, it is believed that this business is located on what was formerly the old Huggins Plantation. (Courtesy of the Sargeant Memorial Room, Norfolk Public Library.)

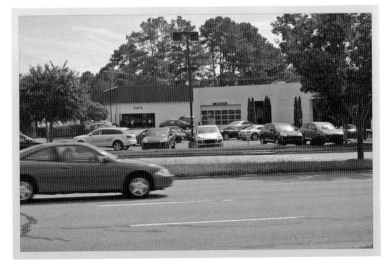

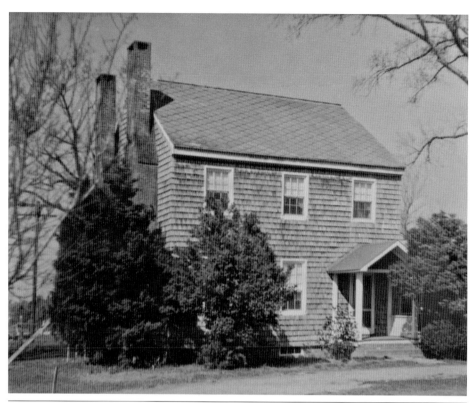

FORREST WOODHOUSE HOUSE, EARLY 1800S. Near the London Bridge corridor, this house was in the Woodhouse family. It is a classic early-19th-century house with two chimneys on the west end and six-over-six windows. As late as the 1960s, the house was visible from the interstate on the north side heading east and appeared to be untouched. Expanded and used for commercial purposes, the Forrest Woodhouse House is now unrecognizable as a historic structure. (Courtesy of the Sargeant Memorial Room, Norfolk Public Library.)

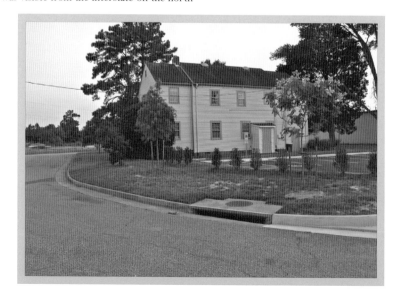

SALISBURY PLAINS. William Cornick's great-grandson, Joel Cornick, was believed to have built Salisbury Plains around 1727 on the original 1657 land patent. It was located in the northeast corner, near Oceana Naval Air Station. The house was frame with brick chimney ends in Flemish bond and beautiful interior paneling. The sill in the basement was described as being 12 inches square and 40 feet in length, an indicator of the size of the trees in early Virginia. It was still in use as a residence in the 1930s but was torn down in 1954 by the navy to build the airstrips at Oceana. (Courtesy of the Sargeant Memorial Room, Norfolk Public Library.)

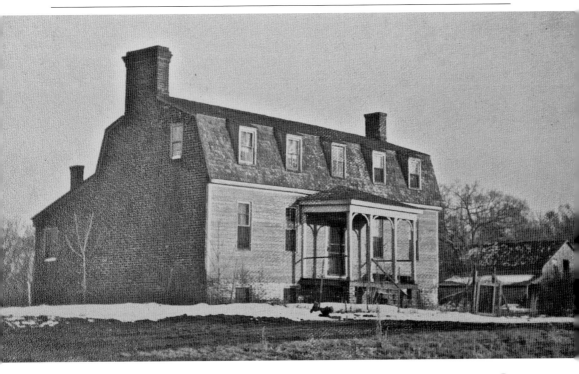

EASTERN SHORE CHAPEL. The Eastern Shore Chapel was a beautiful example of a simple Colonial church. Located in the London Bridge vicinity, it was built in 1726 on lands donated by Joel Cornick, builder of Salisbury Plains. It was replaced by a larger chapel in 1753. The Eastern Shore Chapel met the same fate as Salisbury Plains, dismantled by the navy in 1954. The congregation wanted to rebuild the church in its new location off of Laskin Road, but the old bricks disintegrated and couldn't be used. (Courtesy of the Sargeant Memorial Room, Norfolk Public Library.)

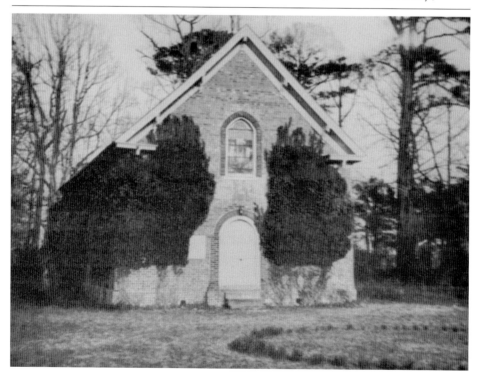

EASTERN PRINCESS ANNE COUNTY

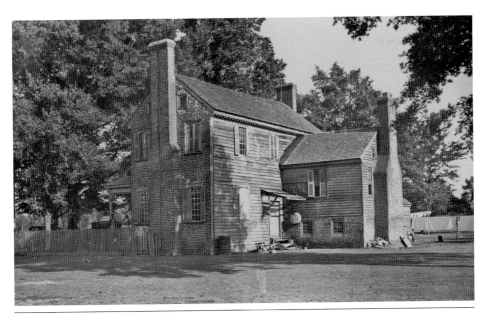

THE HENRY T. CORNICK HOUSE. In 1931, this house stood behind the home of Fannie Colonna, very near Salisbury Plains and the Eastern Shore Chapel. It was believed to have been built before 1800. It was frame with brick ends and exterior chimneys in Flemish bond. The house had all the original woodwork and furnishings, and in one windowpane was etched "John Fortescue / Evelyn Byrd Chamberlayne / February 1807." The ground that once belonged to this house is probably part of Oceana Naval Air Station. The Hunter House near Murden's Corner was likely in this vicinity. (Courtesy of the Sargeant Memorial Room, Norfolk Public Library.)

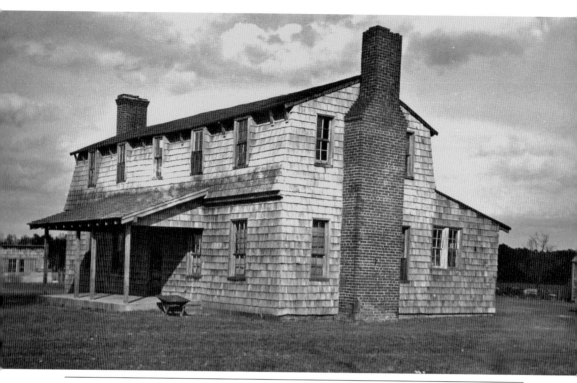

THE BRAITHWAITE HOUSE. The Braithwaite House was built prior to 1800 by James Braithwaite on land purchased from members of the Brock family. It was a five-bay frame house with brick end chimneys. It started as a three-bay house and was expanded over the years. The house was at one time located where Oceana Naval Air Station is now and was probably torn down in the early 1950s. (Courtesy of the Sargeant Memorial Room, Norfolk Public Library.)

THE HUNTER HOUSE AT MURDEN'S CORNER.
There were several early Hunter houses located in the Murden's Corner vicinity. This particular house could have stood off of Potter's Road near present-day Oceana, which may have been called Hunter or Land Road according to an early map. The house was Federal in style, probably built a little after 1800. It had brick ends and interior chimneys on one wall and sat on an English basement. The windows on the first floor appeared to be nine-over-six. (Courtesy of the Sargeant Memorial Room, Norfolk Public Library.)

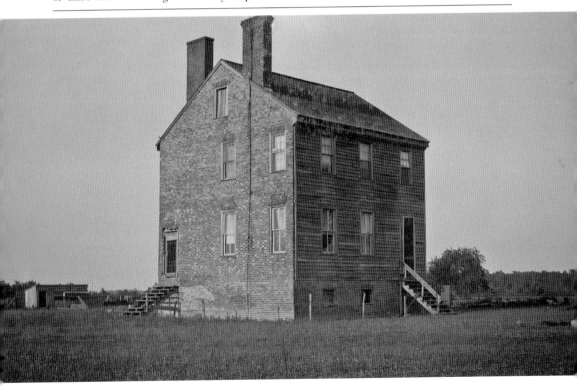

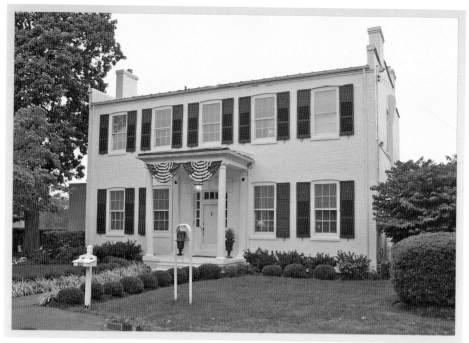

THE JAMES-BELL HOUSE. The property for this house was given by Edward James in 1763 to his son Joshua James II, who built the house in 1820. It is a brick house and has the original flooring and some original window glass. Alexander Bell owned the house at some point and reputedly buried a stash of gold and silver on the grounds. In 1942, A. T. Taylor bought the house and expanded the property to 1,000 acres. It was sold to the navy in 1956 for the air station and is used as quarters for the commanding officer of the base. (Courtesy of Virginia Wesleyan College.)

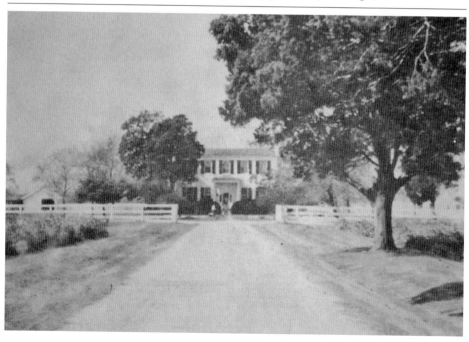

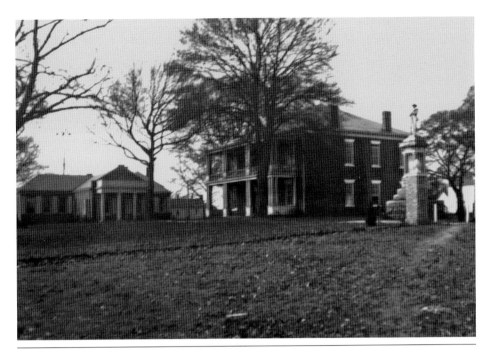

PRINCESS ANNE COURTHOUSE. The village of Princess Anne Courthouse was completed in January 1824, when the location for the courthouse was moved for the fifth time to a 5-acre site. Kempsville and Princess Anne Courthouse were market centers for the agricultural countryside. Princess Anne suffered its largest decline in the population during the agricultural depression in the 1830s. The old section of the courthouse has not changed appreciably over time. (Courtesy of the Sargeant Memorial Room, Norfolk Public Library.)

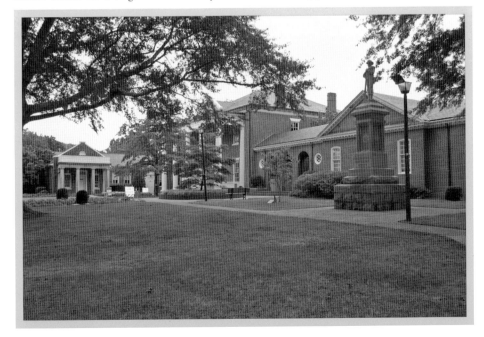

THE WHITEHURST BUFFINGTON HOUSE, *c.* 1793.
There is some debate as to whether the builder of
this house is Francis Whitehurst or his son Daniel.
A chimney brick has the date 1793 etched upon it.
The house was originally clapboard with interior
end chimneys and a gambrel roof. It was originally
a one-room house with a stairway leading to two
small rooms above but was expanded over the
years, which may account for its lack of symmetry.
The siding was replaced at some point with Flemish
bond brick. The chimneys feature the original
brick, and the mantels are reported to be original.
(Courtesy of Virginia Wesleyan College.)

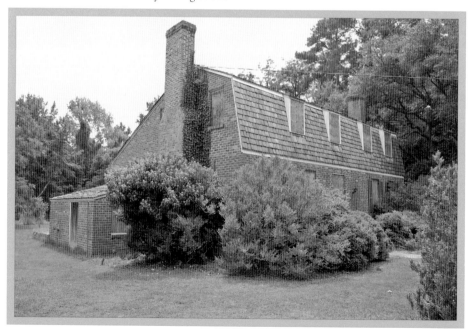

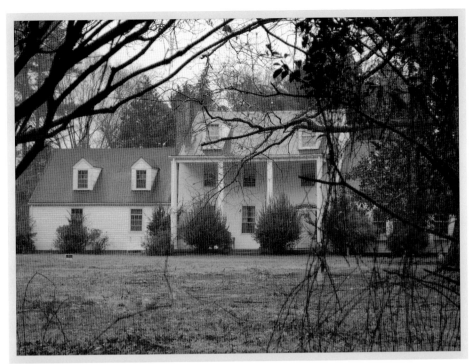

THE VENNER HOUSE, 1700s. This 18th-century Georgian house has remained virtually unchanged for years. It is difficult to tell the difference between photographs taken in the 1940s and present day. A development is being planned for this old house and grounds. The old stables will disappear, and the Princess Anne landmark will get a facelift, but the house will remain, albeit in a different incarnation. (Courtesy of Virginia Wesleyan College.)

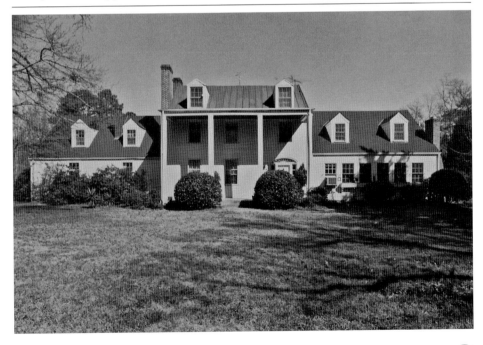

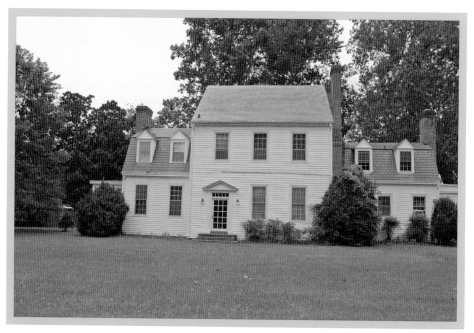

THE BURROUGHS HOUSE, c. 1800. This farm was also known as Cedar Grove and today is called Buyrningwood Farm. It was part of a 200-acre land grant received by Christopher Burroughs in 1683, built by one of his descendants. The grandson of Christopher Burroughs, John Burroughs, was the county clerk from 1821 to 1869. During the Civil War, his son Edgar, a major in the 15th Virginia Cavalry Regiment, CSA, was captured and shot while attempting to escape. He is buried in the family plot to the west of the house. (Courtesy of the owners.)

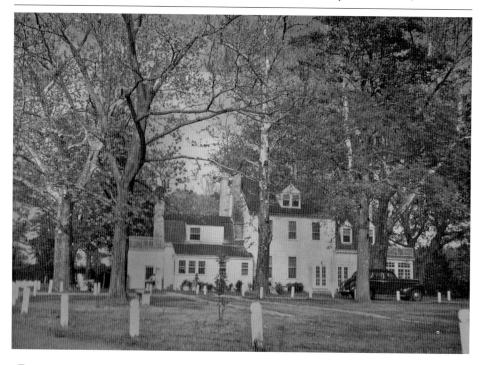

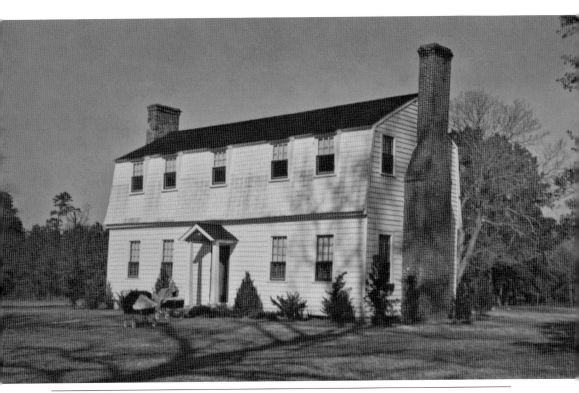

THOMAS LOVETT HOUSE, LATE 1700S. Thomas Lovett built this house prior to his death in 1790. He was a descendant of a Thomas Lovett who had served the county as an undersheriff in 1633. His brother Reuben built a similar house near Princess Anne Courthouse, and their brother Randolph inherited other property. The manor house and plantation was left to his son, Thomas Jr. The house is tucked into a neighborhood off of Holland Road and is being used as a preschool. (Courtesy of the Sargeant Memorial Room, Norfolk Public Library.)

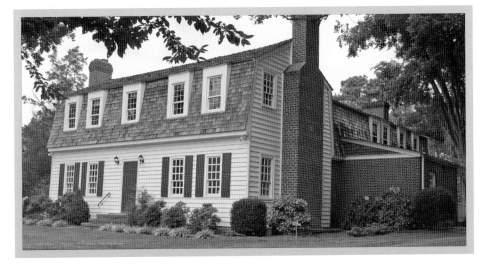

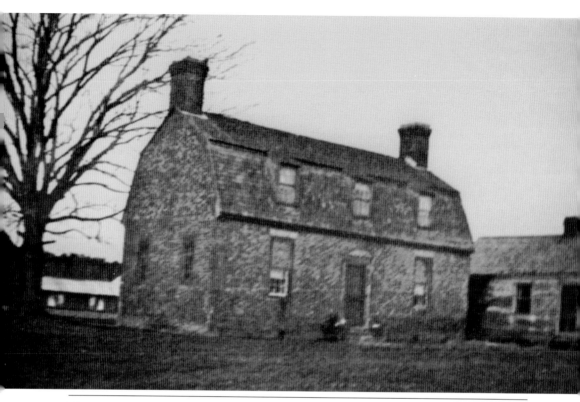

WILLOW GROVE, 1760. The William Woodhouse House was built in 1760 by Capt. William Woodhouse and his wife, Pembroke. On the brick next to the front door are etched the initials W. W. P. The structure is a Dutch Colonial built of 14-inch-thick brick in Flemish bond with original woodwork, heart-of-pine floors, and recessed windows. It was at one time home to the Princess Anne Hunt Club and is now a working farm. (Then photograph courtesy of Sargeant Memorial Room, Norfolk Public Library; now photograph by Nancy Hayes Pope.)

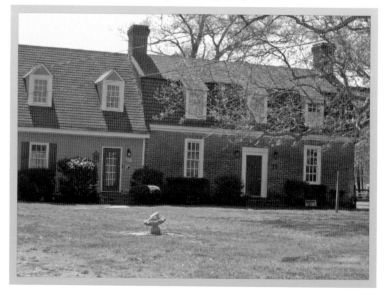

THE HENRY BROCK HOUSE, 1793. In 1635, William Brock came to Charles City County. His son William received a grant for 1,000 acres in lower Norfolk County in 1680. The Brock family prospered, adding to their lands. Ten members of this family fought in the Revolutionary War for the American side. Henry Brock built this house in frame double-end chimney, side-passage style with a gable roof. There is no trace of the Brock House or lands in this Virginia Beach neighborhood. (Courtesy of the Sargeant Memorial Room, Norfolk Public Library.)

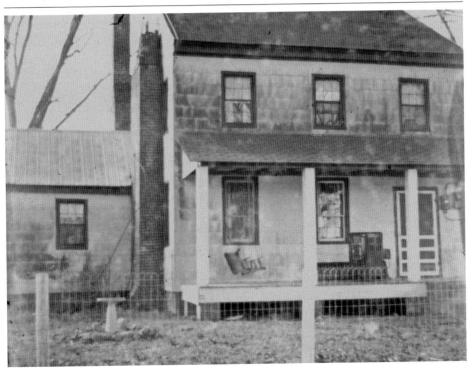

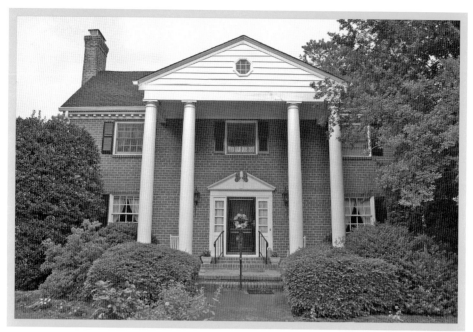

THE JAMES HOUSE, 1790s. Probably built in 1798, the original structure was cypress with brick ends. The Woodhouse family bought the property from Smallwood Thomson around 1840, and it stayed in the family for a century. John T. Woodhouse was a Confederate officer in Mahone's Brigade and was instrumental in erecting the Confederate Monument in front of Princess Anne Courthouse, where he served as county treasurer from 1884 to 1912. In the mid-20th century, its owners extensively remodeled the house, removing many historic details. The old photograph shows an outbuilding surrounded by a vast expanse of acreage. (Courtesy of Mayera E. Oberndorf Central Library.)

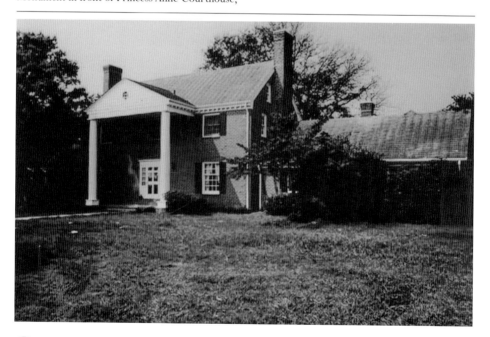

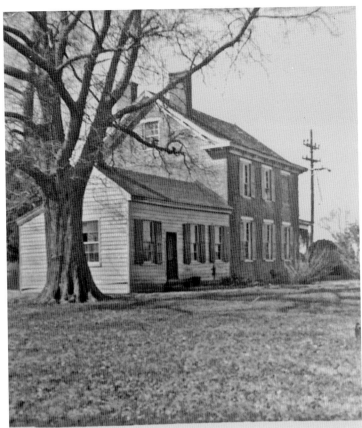

BROWN'S TAVERN, *C.* 1832. Brown's Tavern, also known as the Woodhouse-Hickman House, stands close to General Booth Boulevard, which, at the time it was built, was called the Pungo Ridge Road. It is a strong transitional Federal style with Italianate details. The brick is five-course American bond. The old tavern has been in continuous use since it was first built and has a cluster of period-style outbuildings surrounding it. (Courtesy of the owner.)

JULY 1957

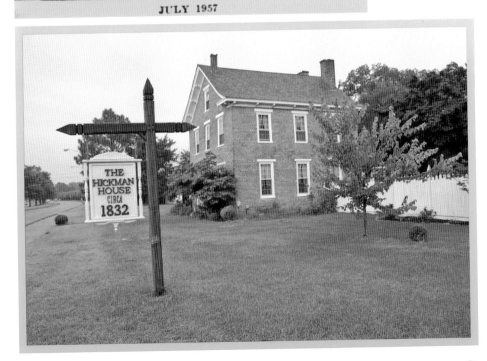

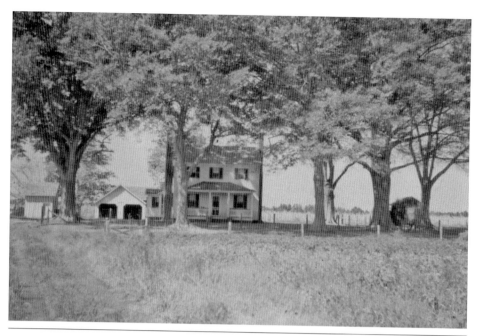

THE THOMAS WOODHOUSE HOUSE, 1810. In the middle of rampant development is a small Federal-style house tucked away in a grove of trees called the Thomas Woodhouse House, or Fountains. Thomas Woodhouse died three years after its construction and is buried in a little plot to the side of the property. The house is two stories with gable ends and exterior chimneys in Flemish bond. Inside are beautiful original mantels, and many of the outbuildings are original. The house is a private residence. (Courtesy of the Sargeant Memorial Room, Norfolk Public Library.)

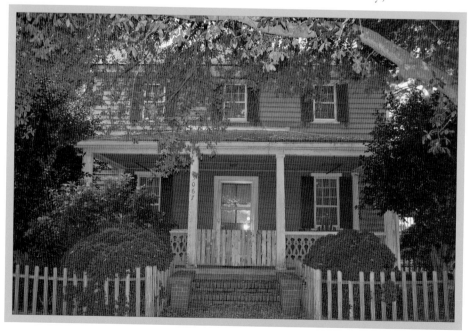

CHAPTER 5

THE PUNGO AND BLACKWATER REGIONS

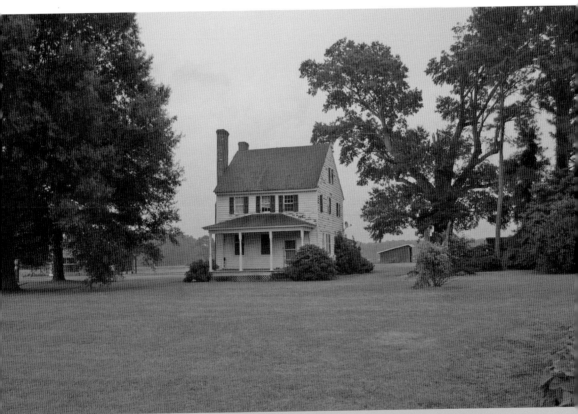

THE OLD IVES HOUSE, c. 1851. The old Ives house is an example of early houses in Princess Anne County that have a side passage plan with double end chimneys. The property on which it sits goes back to an original land patent dating to 1671. At one time, the property was reached through the Pokaty Swamp, and it was purported to have seen military activity. (Courtesy of Timothy McMahon Pope.)

SIGMA. In the 1940s, an outbuilding was all that was left of the Sigma Farm. The house was said to have been gracious and lovely. Today there is no trace of the plantation that stood here, and all that is left is this field and the road that bears its name. (Courtesy of the Sargeant Memorial Room, Norfolk Public Library.)

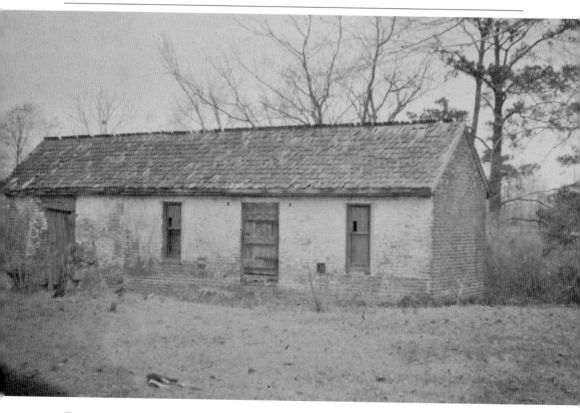

THE PUNGO AND BLACKWATER REGIONS

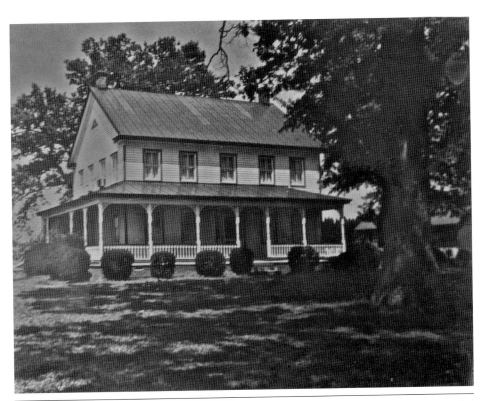

HERITAGE PLANTATION, C. 1826. The Brock family plantation, originally called North Fork Plantation, was built by Ransom Brock, who had expanded his land holdings to 8,000 acres by 1860. According to the current owner, each Brock added their personal stamp upon the house, which started as a one-and-a-half-story structure and was expanded over the years. The name Heritage Plantation was given to the home by the current owner. The historical photograph shows the house as it was in 1910. (Courtesy the owner.)

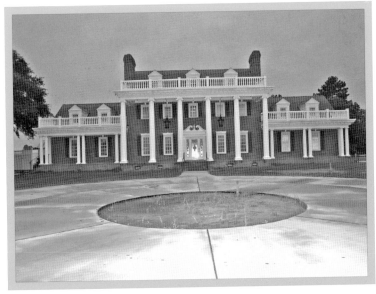

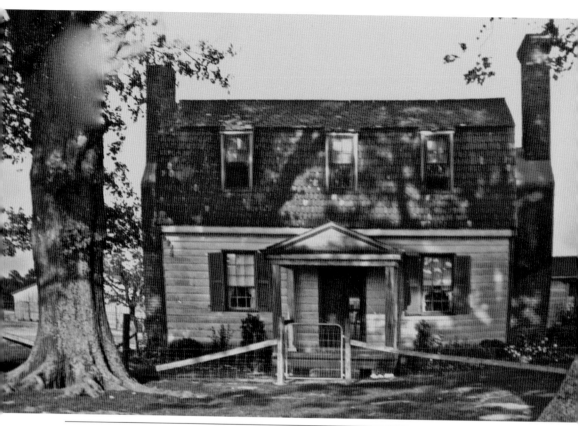

THE J. A. FENTRESS HOUSE, C. 1794. The charming frame house with brick exterior chimneys and gambrel roof that once stood on this site was originally part of the old Land farm and was eventually acquired by the Fentress family. There is a happy ending for this particular house—it was dismantled in the mid-1980s and restored in a new location in Hanover County outside Richmond. A ranch house occupies the site today. (Courtesy of the Sargeant Memorial Room, Norfolk Public Library.)

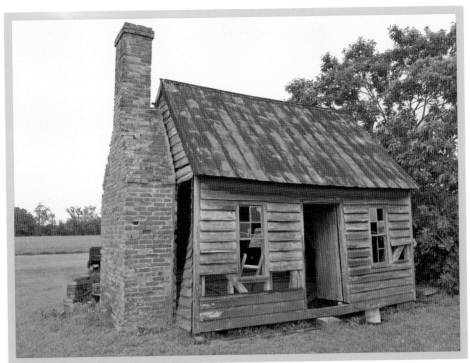

THE J. A. FENTRESS HOUSE. The old slave or quarter kitchen still stands on the property. The land is still being farmed, and an old family cemetery dating to the mid-19th century stands in the middle of the site, surrounded by a beautiful iron fence. Owner Garland "Jack" Fentress is shown in front of the house as it was being moved in 1986. (Photograph courtesy of *Virginian-Pilot / Ledger-Star.*)

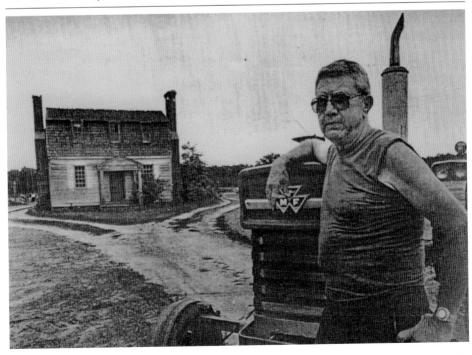

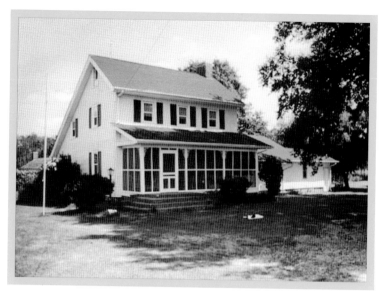

ANTHONY FENTRESS HOUSE, *c.* **1770.** The house was built before 1772 and was adjacent to Capp's Store and Pungo Chapel, the ruined foundation of which could still be seen in the 1930s in the field of the old Fentress farm. It is a frame house with brick ends, with a side passage and two-room floor plan. In 1931, Sadie Kellam stated that the "house had been added to, the interior greatly changed. From the road, one would suppose it was a very modern home." The house is privately owned. (Courtesy of the Sargeant Memorial Room, Norfolk Public Library.)

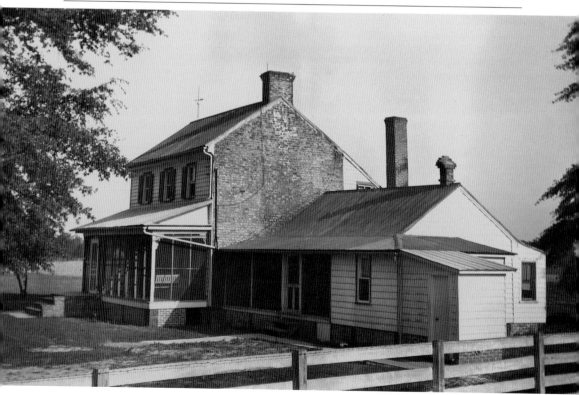

THE PUNGO AND BLACKWATER REGIONS

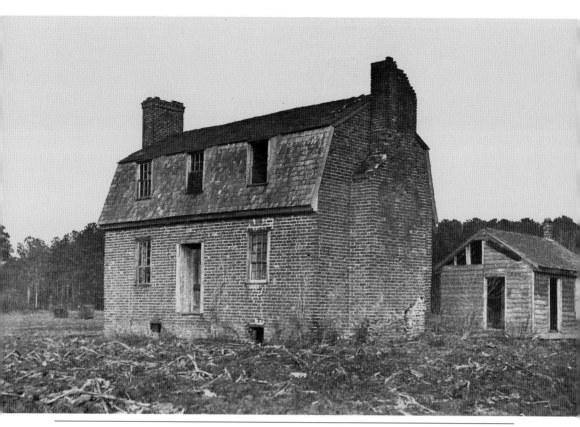

BLOSSOM HILL, 1732. Blossom Hill took its name from the profusion of wildflowers that bloom here during the spring. Francis Ackiss bought the land and built the house in 1782, and his initials and the date are found on the southern gable. The house had a gambrel roof and was made of 19-inch-thick brick laid in Flemish bond. There were two rooms upstairs and two rooms downstairs. A subdivision named Blossom Hill sits on the location of the old plantation. (Courtesy of the Sargeant Memorial Room, Norfolk Public Library.)

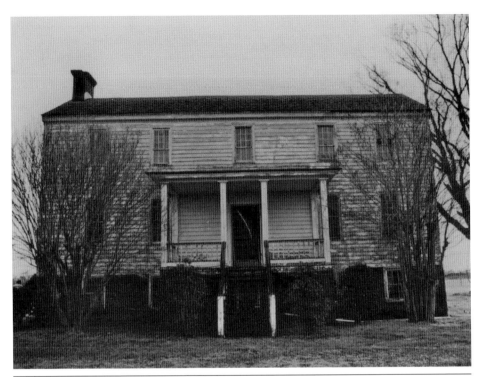

THE BAXTER (FROST) FARM, 1790–1820. This five-bay farmhouse was built by a local doctor named Isaac Baxter in 1790 and expanded later. The home is in vernacular Federal style, with an inverted chimney on a raised foundation of three-course American bond. Local history has it that slaves were kept in the English basement of the house. It has been maintained over the years and has a nice location a distance off of a two-lane road. (Courtesy of the owners.)

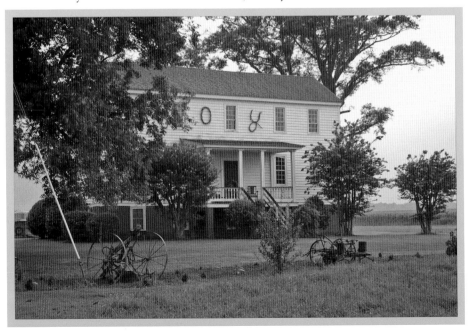

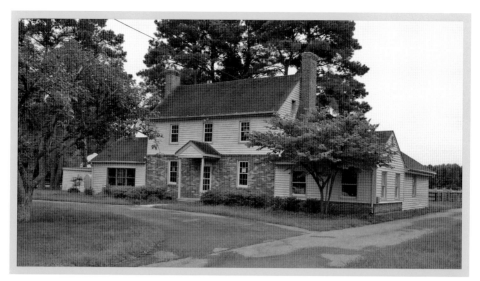

THE BONNEY HOUSE. In the 1940s, this early-19th-century house stood alone in a field awaiting restoration. Today the restored Bonney House no longer sits in the middle of a vast field by itself but rather is on a quiet back road with other houses as neighbors. (Courtesy of the Sargeant Memorial Room, Norfolk Public Library.)

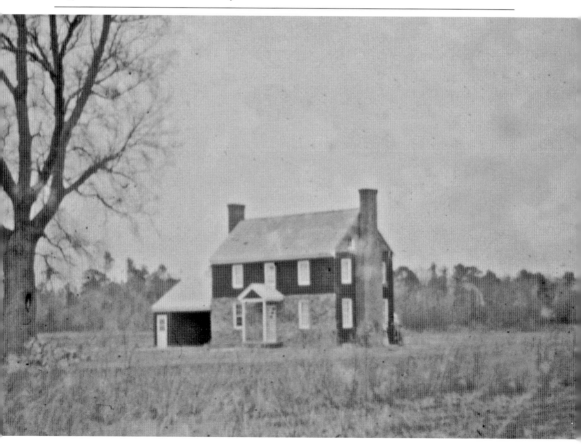

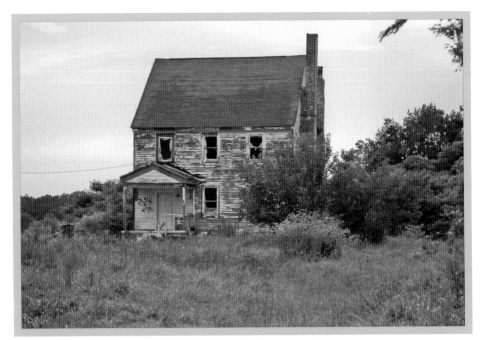

NEW BRIDGE ROAD. The Pungo area of Virginia Beach is full of old houses like this one that reflect a culture and a way of life that most of us will never know. Many of these houses have been passed down from one generation to another; many others, such as this one, have origins that are difficult to trace. This house is located on New Bridge Road. (Courtesy of the Sargeant Memorial Room, Norfolk Public Library.)

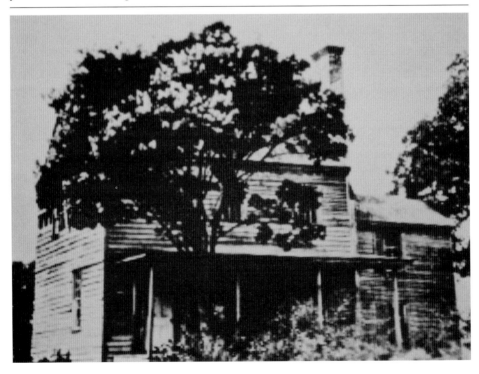

CHAPTER 6

VIRGINIA BEACH'S OCEANFRONT

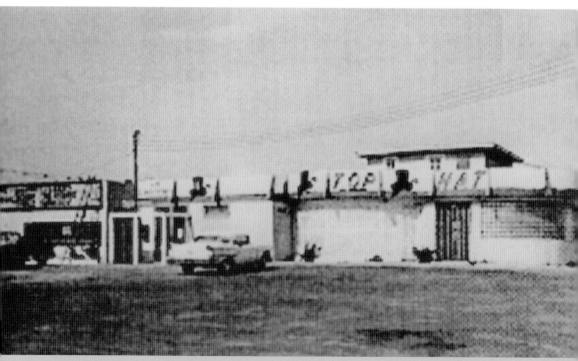

THE TOP HAT. In the 1950s and 1960s, the Top Hat was a popular local venue for musicians who came from far and wide to play here. The upstairs room was the studio for local celebrity deejays Dick Lamb and Gene Loving. (Courtesy of billdealonline.com.)

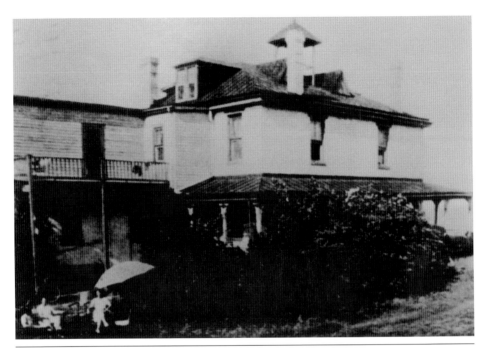

THE DEWITT COTTAGE, C. 1895. The deWitt Cottage was built by the city's mayor and first postmaster, Bernard P. Holland. In 1909, it was bought by Norfolk banker and cotton broker Cornelius deWitt, who lived there with his wife and 10 children. The family called the cottage *Wittenzand* (White Sands) and operated it as a guest house during the Great Depression. Three daughters stayed in the house until 1988. It is the oldest structure left at the oceanfront and is home to the Atlantic Wildfowl Museum and the Back Bay Wildfowl Guild. (Historic photograph courtesy of Tom Beatty.)

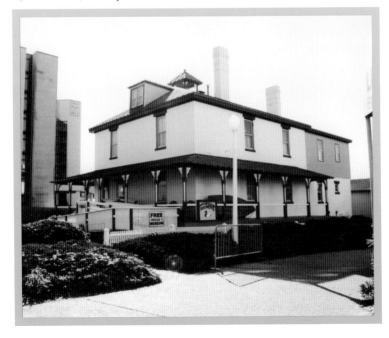

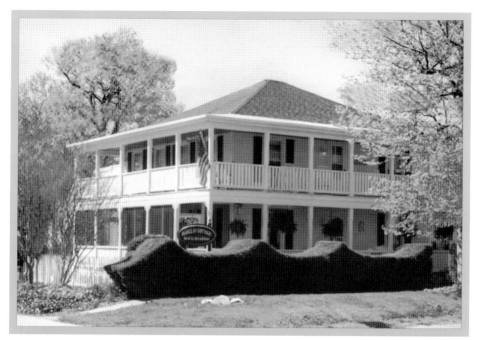

THE BARCLAY COTTAGE, C. 1895. This charming cottage is the oldest lodging facility in the greater Tidewater area. It was built as a clubhouse by the Norfolk and Virginia Beach railroad for a golf course that never came to fruition and was acquired in 1916 by the family of Lillian Barclay, who opened it as a small hotel in 1917. The renowned psychic Edgar Cayce was a friend of Barclay's and held several of his readings at the cottage. It is one of only two original cottages left. The cottage is a bed-and-breakfast. (Courtesy of Meyera E. Oberndorf Central Library.)

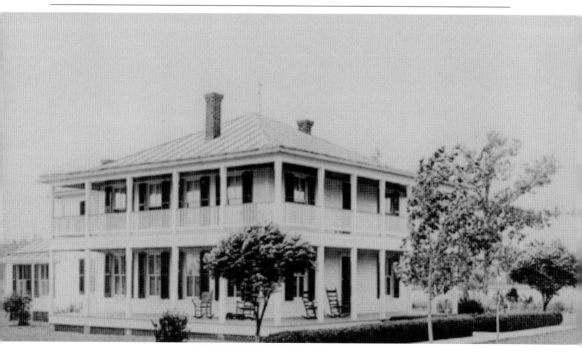

THE VIRGINIA BEACH DOME. The Virginia Beach Dome, designed by Buckminster Fuller, was the first geodesic dome built in the continental United States. It was constructed in 1958 by the Globe Iron Construction Company. The Dome attracted the biggest bands of its time, like the Animals, the Who, and the Rolling Stones. It was demolished in 1994 for a parking lot. (Courtesy of *Virginian-Pilot*.)

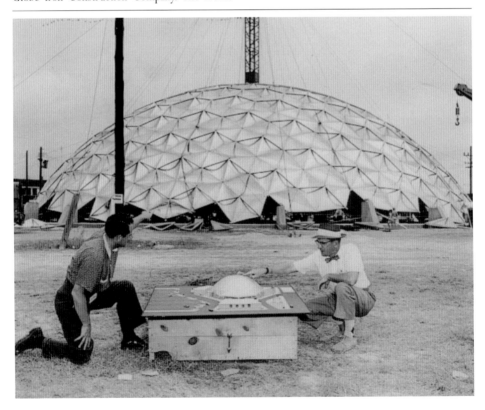

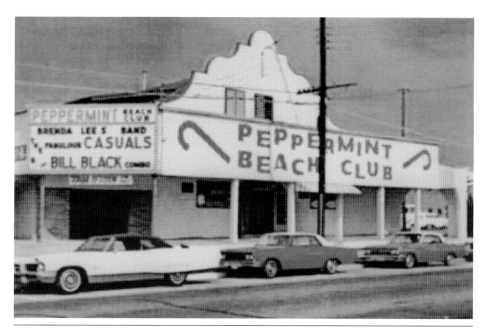

THE PEPPERMINT BEACH CLUB. The Peppermint Beach Club, called the "Home of Beach Music," stood at the end of the old wooden pier at the oceanfront. It was a popular dance hall in the 1960s, a great venue for bands like Bill Deal and the Rhondels, Sebastian and his House Rockers, and Little Willie and the Impressions. It was torn down for a parking lot in 1995. (Courtesy of Meyera Oberndorf Public Library.)

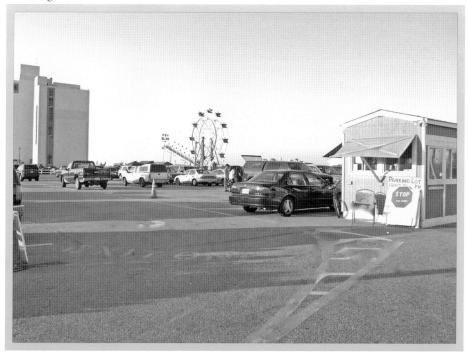

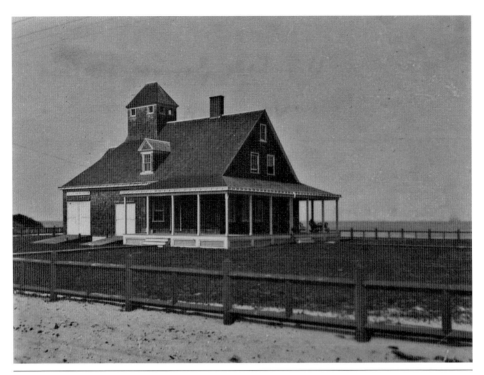

LIFE SAVING STATION, *c.* 1903. This small building, dwarfed by towering hotels, has weathered storms for over 100 years. The treacherous waters of the Atlantic have been the cause of hundreds of shipwrecks, whose remains are still being uncovered after every storm by people combing the beach. This small station, standing sentinel on what would then have been a lonely stretch of beach, housed the courageous men who would brave the stormy seas to rescue those in peril. It is a museum and is open to the public. (Courtesy of the Sargeant Memorial Room, Norfolk Public Library.)

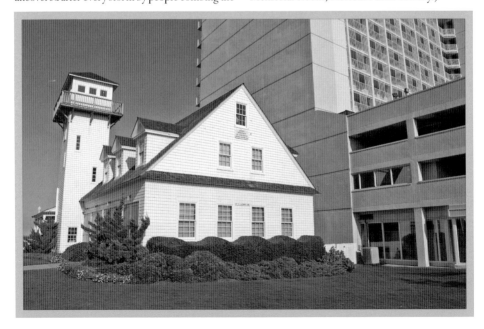

THE VIRGINIA BEACH HOTEL, 1885. The Virginia Beach Hotel was the jewel of the oceanfront, attracting such luminaries as Alexander Graham Bell, Cornelius Vanderbilt, William Jennings Bryan, Pres. Benjamin Harrison, and the widow of J. E. B. Stuart. It was renamed the Princess Anne in 1887 and was known for dances and grand cuisine. It burned in 1907 from a fire blamed on a defective flue in the kitchen. A chambermaid and a steward perished in the blaze, and the distraught manager tried to end his life by jumping into the ocean but was restrained by friends. Today huge hotels line the boardwalk. (Courtesy of the Sargeant Memorial Room, Norfolk Public Library.)

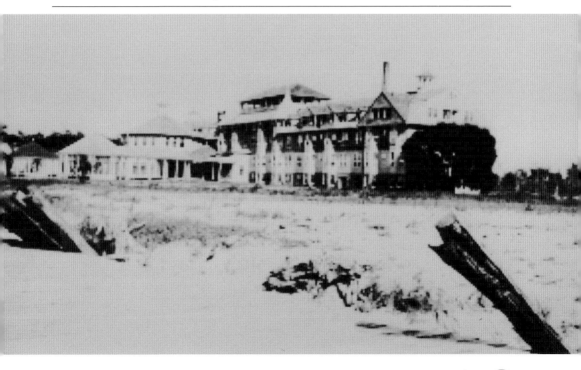

VIRGINIA BEACH'S OCEANFRONT

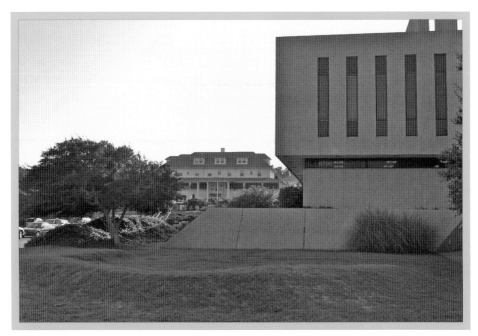

THE EDGAR CAYCE HOSPITAL, c. 1928. Perched on a rise overlooking the ocean at Sixty-seventh Street, the Edgar Cayce Hospital was built in the style of the beach hotels of the time, featuring open verandas to catch the prevailing breezes. The famous psychic used this as his center until forced to close in 1931 due to the Great Depression. After various use as a club, a theater for summer stock, and a hotel, the building was purchased by the Association for Research and Enlightenment in 1958. The modern photograph shows the juxtaposition between the old hospital and the new center. (Courtesy of the Edgar Cayce Museum.)

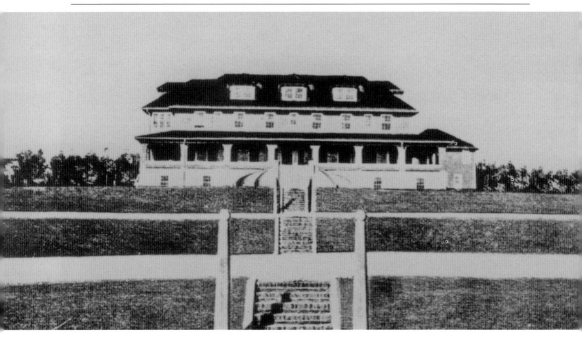

VIRGINIA BEACH'S OCEANFRONT

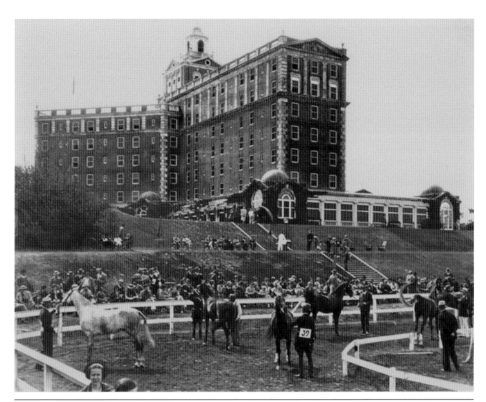

THE OLD CAVALIER HOTEL, c. 1927. The Cavalier opened its doors to guests in 1929 to the music of the McFarland twins, former saxophonists of the Fred Waring Orchestra. Over the years, all the big band names played here, including Sammy Kaye, Benny Goodman, Les Brown, Cab Calloway, Jimmy Dorsey, Artie Shaw, and Lawrence Welk. It was the frontrunner of the beach clubs and offered guests a golf course patterned after courses in Scotland landscaped in flowers from the Cavalier gardens. It had its own trolley stop, and the old horseback riding trails to the stables still run through the neighborhood. In World War II, it served as a naval radar training center. The Cavalier still operates as a hotel. (Courtesy of the Sargeant Memorial Room, Norfolk Public Library.)

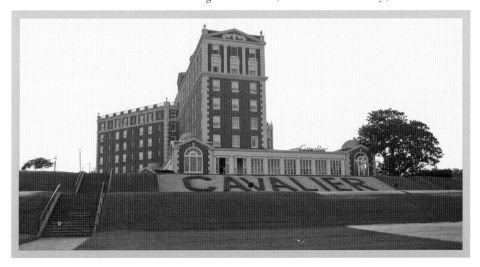

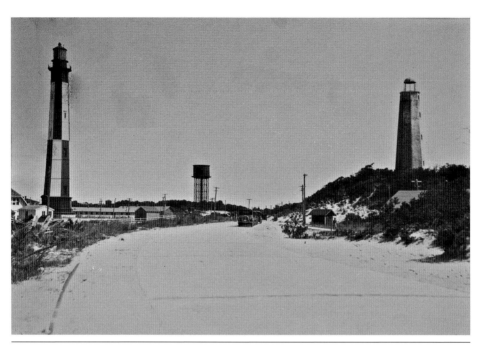

THE LIGHTHOUSES AT CAPE HENRY, 1792 AND 1870. It seems fitting to end with Cape Henry, which is also called First Landing. The old lighthouse, sitting high upon a dune, was built in 1792 but was replaced with the newer lighthouse in 1870 when it cracked. The old lighthouse is owned by the Association for the Preservation of Virginia Antiquities and is a historic landmark open to the public. The new lighthouse is still in use as an active aid in navigation. The historical photograph shows the sand surrounding the old lighthouses. The modern photograph shows vegetation covering the same the area. (Courtesy of the Sargeant Memorial Room, Norfolk Public Library.)

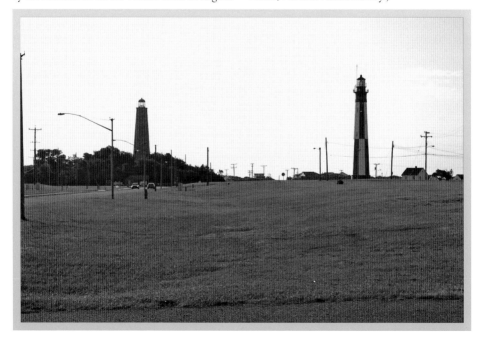

BIBLIOGRAPHY

50 Most Historically Significant Houses and Structures in Virginia Beach. Virginia Beach: Virginia Beach Historic Preservation Partnership, 2008.

Archaeological Assessment of the Chesopeian Site. Virginia Beach: James River Institute for Archaeology, December 2006.

www.carolshouse.com

www.city-data.com/article/Lynnhaven-House-Virginia-Beach-Virginia.html

www.fairfieldcivic.org

Faulconer, Anne M. *The Virginia House: A Home For 300 Years.* Exton, PA: Schiffer Publishing, 1984.

Gilbert, Lillie, Belinda Nash, and Deni Norred Williams. *Bayside History Trail: A View from the Water.* Virginia Beach: Eco Images, 2003.

www.historichotels.org

Historic Resources Management Plan: History of Virginia Beach and Its Resources. Virginia Beach: City of Virginia Beach, 1994.

Kellam, Sadie. *Old Houses of Princess Anne, Virginia.* Portsmouth, VA: Printhouse Press, Inc., 1958.

www.kempsvillebaptist.com

Lost Virginia: Vanished Architecture of the Old Dominion. Richmond: Virginia Historical Society, 2001.

www.oldcoastguardstation.com

www.rolleston.org.uk

Yarsinske, Amy Waters. *Virginia Beach: A History of Virginia's Golden Shore.* Charleston, SC: Arcadia Publishing, 2002.

Discover Thousands of Local History Books Featuring Millions of Vintage Images

Arcadia Publishing, the leading local history publisher in the United States, is committed to making history accessible and meaningful through publishing books that celebrate and preserve the heritage of America's people and places.

Find more books like this at
www.arcadiapublishing.com

Search for your hometown history, your old stomping grounds, and even your favorite sports team.